STEAMPUNK EMPORIUM

STEAMPUNK EMPORIUM

◆

CREATING FANTASTICAL JEWELRY, DEVICES
AND ODDMENTS FROM ASSORTED COGS,
GEARS AND OTHER CURIOS

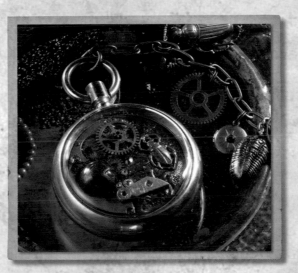

Tales Curated by

Jema "Emilly Ladybird" Hewitt

NORTH
LIGHT
BOOKS

CINCINNATI, OHIO

Edited by Julie Hollyday
Cover design & art direction by Kelly O'Dell
Interior designed by Marissa Bowers
Design layout by Steven Peters
Production coordinated by Greg Nock
Photography by Jema Hewitt, Ric Deliantoni
Photography styling by Jan Nickum

www.fwmedia.com

15 14 13 12 5 4 3 2

DISTRIBUTED IN CANADA BY
FRASER DIRECT
100 Armstrong Avenue
Georgetown, ON, Canada L7G 5S4
Tel: (905) 877-4411

DISTRIBUTED IN THE U.K. AND EUROPE BY
F&W INTERNATIONAL
Brunel House, Newton Abbot, Devon, TQ12 4PU, England
Tel: (+44) 1626 323200, Fax: (+44) 1626 323319
Email: enquiries@fwmedia.com

DISTRIBUTED IN AUSTRALIA BY
CAPRICORN LINK
P.O. Box 704, S. Windsor NSW, 2756 Australia
Tel: (02) 4577-3555

METRIC CONVERSION CHART

TO CONVERT	TO	MULTIPLY BY
Inches	Centimeters	2.54
Centimeters	Inches	0.4
Feet	Centimeters	30.5
Centimeters	Feet	0.03
Yards	Meters	0.9
Meters	Yards	1.1

DEDICATION

THIS BOOK IS DEDICATED WITH GREAT AFFECTION

TO

THE COMPANY OF CRIMSON,

WHOSE CAPACITY FOR TEA,

CAKE AND ADVENTURE

SOMETIMES SURPRISES EVEN ME.

AND ALSO TO MY NEPHEW AND

SMALLEST ADVENTURER, ISAAC.

TABLE OF CONTENTS

WHAT IS STEAMPUNK? {8}

ATLANTIS EXPEDITION {10}

Oceans Gate Key Device	12
Atlantean Starlight Necklace	16
Azure Cog Earrings	20
Mermaid Song Bracelet	24

ZEPPELIN PIRATE ATTACK! {28}

Storm Bringer Device	30
Zeppelin Pirate Necklace	34
Aether Pirate Cravat Pin	38
Zeppelin Skull and Cogbones Ring	42

ABSINTHE FAIRY INTERLUDE {46}

Brass Wings Necklace	48
Absinthe Glass Charms	52
Green Fairy Cufflinks	56
Absinthe Fairy Charm Bracelet	60

JURASSIC VALLEY EXPLORATION {64}

Adventurer's Fob Watch	66
Empire Medal	70
Adventurer's Necklace	74
1st Lunar Regiment Dog Tags	78

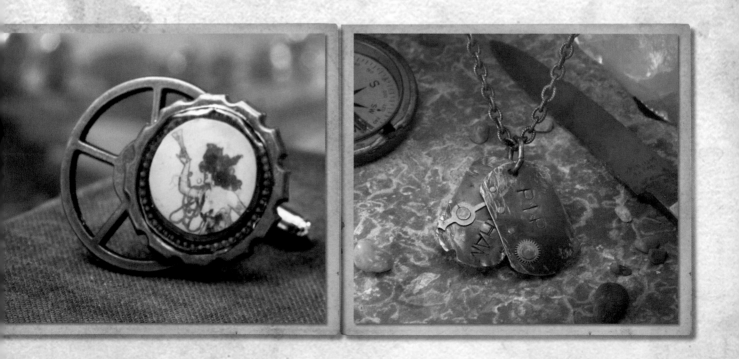

CLOCKWORK
TEA PARTY {82}

Teapot Brooch 84
Clockwork Princess's Chatelaine 88
Cog Button Choker 92
Clockwork Hatpin 96

An Appendix of Useful Items and
Practical Methodology [100]

Acknowledgments [122]
About the Author [123]
Resources [124]
Index [126]

What is Steampunk?

This has become an increasingly difficult question to answer, especially as the steampunk movement increases and expands in popularity, reinventing itself as it goes!

Steampunk, at its most basic, is Victorian-style science fiction. As a genre it covers books, art, music, films, clothing and jewelry, all bound together by a fantastical yet historical premise: that the world, instead of discovering electricity and silicone chips, continues to be paused in the 1800s, powered by steam and clockwork. What might have happened if Victorian inventor Charles Babbage had finished his mechanical computer, the Analytical Engine (which can still be seen in London's Science Museum today)? What if the earth really was hollow with another world inside, and the only way to it was by a steam-powered mole machine? What if it was possible to sail the aether winds in a pressurized airship to alien-inhabited planets?

Unlike other fantasy genres that rely on magic to provide a world difference, steampunk is based on mechanisms and machines, gadgets and gizmos. Most of these retain Victorian stylings of brass, mahogany and fine metal filigree, harking back to an era when machinery wasn't just useful but beautiful as well. There are often fantasy elements included—the Victorian obsession with fairies, vampires and the supernatural—that influence the modern genre.

The author popular at the very beginning of all this whimsy was Jules Verne. Verne was born in 1828 in Nantes, France, and even as a child had a passion for travel and adventure, once attempting to stow away on a ship bound for India! He wrote the very first books of what we would later come to call "science fiction"—stories of exploration into space and the future; of course, at the time he was writing about contemporary people in fantastical situations. Many of his stories are still familiar to us today through screen adaptations of *A Journey to the Center of the Earth*, *Around the World in 80 Days* and *20,000 Leagues Under the Sea*.

The actual phrase "steampunk" appeared almost 150 years later when authors William Gibson and Bruce Sterling wrote their alternate-history novel *The Difference Engine*. They had already written many novels in the 1970s and '80s in the futuristic sci-fi genre called cyberpunk. It is thought that another author K.W. Jeter referred to this book in a review as "steampunk" because it had a historical Victorian setting. Politics and satire, often bordering on the revolutionary, permeated these new novels, as it had the science-fiction writings of Verne, Poe and H.G. Wells.

For many people, steampunk is a way of life. They may dress in Victorian-inspired clothes, including button boots and corsets, cravats and bowler hats. Some steampunkers dress like this all the time, some just on weekends and for special events. They may create their own beautiful machines, like brass and wood computers and filigree bluetooth telephones, some of which work, while others are just *objets d'art*. There are those who like a dark and sinister steampunk style, while others take a more historical angle. And then there are the ones who just like Victorian space pirates—Huzzah! Steampunkers love getting together and having tea parties and balls, telling stories, going on adventures and admiring steam engines. Some play in bands, some in orchestras. But above all they are creative, well mannered and have fun!

It is my sincerest wish that you will find all the wit and whimsy of steampunk in this tome. I am so excited to share this wonderful world with you through items to wear, devices to aid you in expeditions and oddments at which to marvel. I can't wait for you to join me in my adventures and hope you may find new inspiration for some amazing stories and characters within the pieces you create.

Emilly Ladybird

H. Hemmins SWINDON
 VICTORIA STREET

9

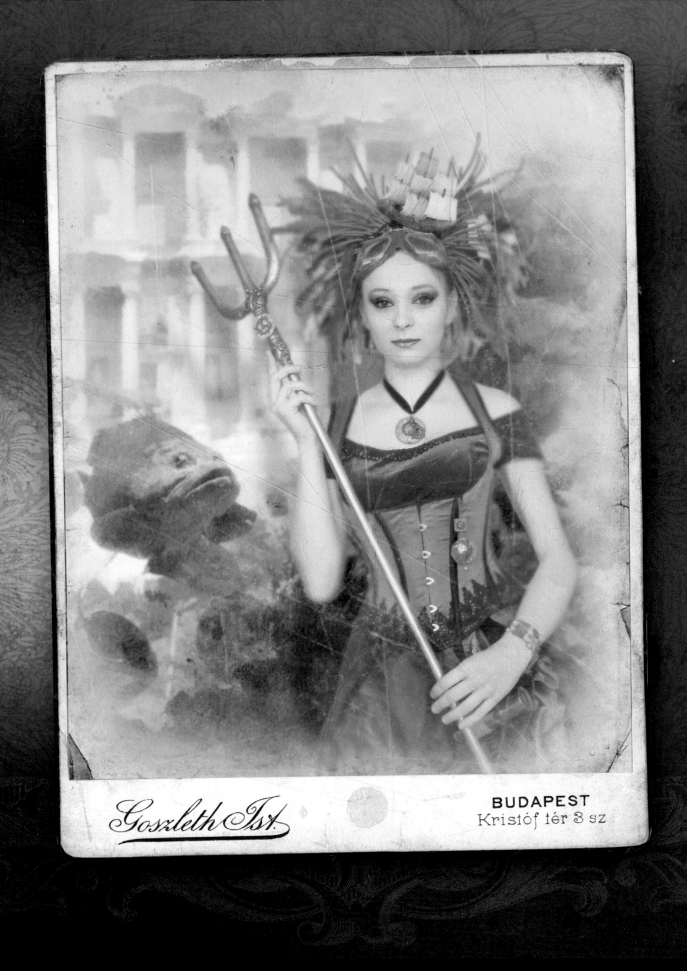

Goszleth Ist.

BUDAPEST
Kristóf tér 3 sz

Atlantis Expedition

---◈---

TO THE EDITOR, *The Times*,

Without doubt, Undine Petrides's discovery of Atlantis must be considered an extraordinary achievement. For such a young explorer to rediscover an entire civilization, especially within the inky depths of over 20,000 leagues, is unparalleled. The Atlanteans themselves believe Undine to be "Valoeen," a lost descendent of a noble Atlantean family, exiled many centuries ago for wanting contact with the upper world.

Atlantean thought has progressed much since those distant times, and Undine has been welcomed as an honorary citizen. To date, only eight others have been privileged to descend in her patented submersible and view the wonders of Atlantis. I was thrilled to accompany Miss Petrides for her Citizens Accolade during a gala ceremony.

The whole city was illuminated with a phosphorescent glow that rippled and shimmered, constantly changing hue. Huge sea creatures swam above us, their massive forms like shadows in the deep. The honor guard first appeared, clad in ceremonial robes. Undine and I followed in our compression suits, which, like the submersible, were entirely of her own design. We were seated on a marble dais for the ceremony, which lasted several hours. There was dancing, whale song and a glorious feast. Finally, however, our breathing tanks were nearly empty; we returned to the aerated ship and, from there, climbed back toward the light.

YOUR INTREPID CORRESPONDENT,

Emilly Ladybird

Oceans Gate Key Device

ONLY THE TWELVE HEADS OF THE MOST ANCIENT FAMILIES OF ATLANTIS are given the secret gate key. Its mechanism, though small, allows the huge doors of Atlantis to swing wide by no visible means. Undine Petrides made some measured drawings of the gates on her last visit and presented a paper on its mechanism to the Royal Society last spring.

This key is Undine's own and had been kept as an heirloom in her family for generations. The huge sapphire is called "the stone of destiny" and signifies swift intelligence and courageous perception. Her close friends were heard to snort with laughter upon hearing this. I cannot imagine why. The other eleven keys each have a different gem signifying a different characteristic in Atlantean society.

SUPPLIES

Open-backed porthole spacer finding (from Objects and Elements) or suitable bezel

2-part epoxy resin

Oil paint (blue, green)

Micro glitter

Teeny cogs

Scrap polymer clay (about ½ oz)

Tiny detailed objects for texture plate

Polymer clay in gray, sea green and translucent (about ¼ oz each)

Brass plate from the inside of a pocket watch (or large brass disk with a hole through the top and bottom)

10mm crystal chaton (must be glass, not plastic)

3 or 4 medium-sized brass cogs, approximately ½" (1.5cm) in diameter

Silver powder

Acrylic paint (ocean green)

Large peach pearl (6mm)

Antiqued brass headpin

0.4mm antiqued brass wire, approximately 10" (25.2cm) long

3mm antiqued brass jump ring

Antiqued brass chain

Antiqued brass clasp

EQUIPMENT

Sticky tape

Cocktail sticks

Small paper or plastic cups

Modeling tools

Paintbrush

Cotton swab or sponge

Round-nose pliers

Wire cutters

INQUIRE WITHIN

You will need only a teeny bit of resin for this project, so it's a good idea to do several resin projects at once.

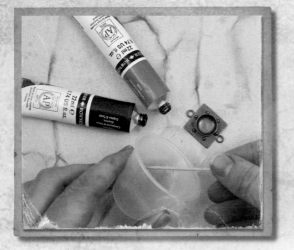

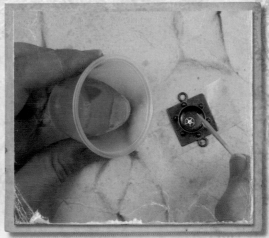

Step 1 Cover the back of the porthole spacer with a piece of sticky tape, making sure it is completely sealed. Weigh out the minimum amount of resin suggested by the manufacturer and mix it thoroughly with the cocktail sticks in a small plastic cup. Use the cocktail sticks and oil paints to add a light tint of ocean color to the resin. Carefully fill a third of the bezel with the resin. Leave the bezel to cure for at least 6 hours.

Step 2 Mix up a second batch of resin and tint as before. Mix in a pinch of glitter to add an undersea sparkle. Gently place a tiny cog on the resin layer in the porthole. Using the cocktail stick, drip the fresh resin into the bezel until the bezel is two-thirds full. Allow the resin to set for another 6 hours.

Finally, repeat the process for a third time, adding more tiny cogs and omitting the glitter, filling the bezel to the top. Allow the bezel to cure fully (approximately 24 hours).

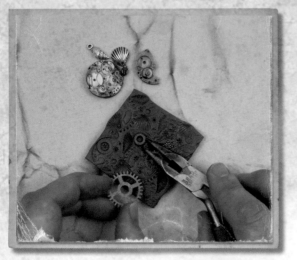

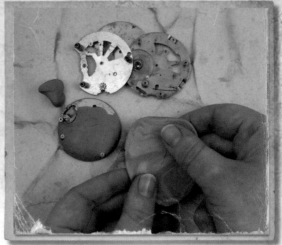

Step 3 Create a texture plate by rolling out a piece of scrap polymer clay and impressing tiny and detailed objects into it. A texture plate allows the design to stand out from the clay rather than be embossed into it. The plate needs to be only 1" (2.5cm) or so across (mine is a little large). When you are happy with the texture, bake the clay according to the manufacturer's instructions. Allow the clay to cool.

Step 4 Condition and then blend the green, gray and translucent clays together to make a stonelike marbled pattern (see Conditioning on page 116). Roll it out to about $^1/_8$" (3mm) thick. Take the brass back plate, press scrap clay onto it and roughly sculpt a rock shape that comes up to about $^1/_2$" (1.5cm) on one side and falls away to nothing on the other. Smooth the marbled clay over this shape and trim as needed. Use modeling tools to neaten if necessary.

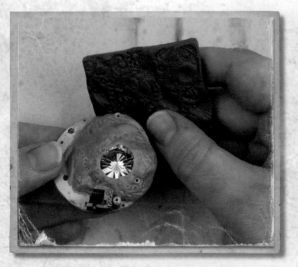

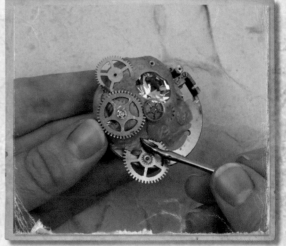

Step 5 Press the large crystal into the clay, scooping out some of the clay behind the crystal if it has a deep pointed back. Smooth the clay over its edges to hold the crystal in place, and soften around the shape. Spray the texture plate with water to prevent sticking, and press all over the marbled clay. If some areas seem a little bare, use additional cogs and tools to texture the clay more.

Step 6 Press the large cogs into the clay. Some can be pushed sideways into the clay; then smooth the clay down around the spokes with a modeling tool to secure firmly. Make sure the cogs don't extend too far sideways from the original back plate. If one has a "stem" still attached, you can push it straight down into the clay. Try to keep a realistic interlocking grouping.

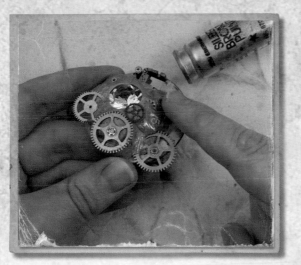

INQUIRE WITHIN

Wiping off some of the paint allows you to see the lovely silver shine on the highlights while still seeing some of the original rock color. If your sponge is too damp, or the texture is not pronounced enough, you may wipe off all the paint by mistake.

Step 7 Pick up a little silver powder with your finger and shake most of it off. Gently dust the raised areas of the clay, giving it a subtle silver sheen. Don't swamp it; you still want to see parts of the marbled colors, too. Bake the piece according to the clay manufacturer's instructions. Make sure you give it the full allotted time; it's quite a solid lump of clay! Allow the clay and metal to cool before handling the piece further.

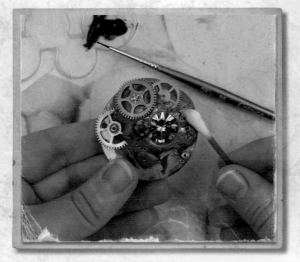

Step 8 Using an ocean-green color of thick acrylic paint, work the paint down into the recesses of the piece with a brush and immediately wipe off the highlights with a slightly damp sponge or cotton swab.

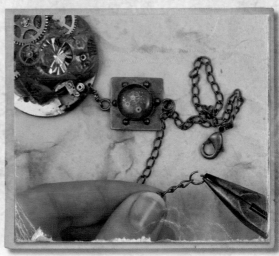

Step 9 To combine the elements, thread the large pearl onto the headpin and make a wrapped loop, suspending the pearl from the bottom of the piece as you do so (see Wrapped Loop on page 113). Attach the key device to the porthole bezel in the same way, using a double wrapped loop. Finally, attach a large jump ring to the top of the porthole and thread your chain through. Adjust it to your preferred length, and attach the clasp.

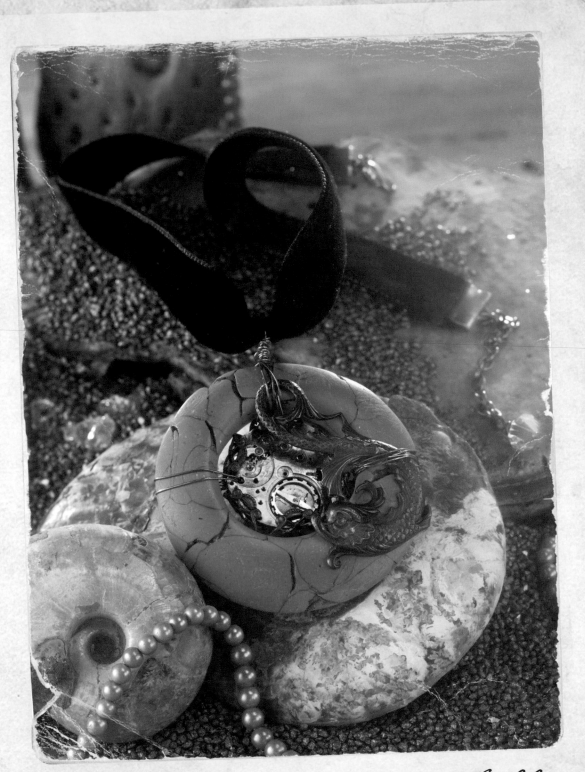

Atlantean Starlight Necklace

DOLPHINS ARE ACCEPTED AS EQUALS BY ATLANTEANS. To further ease communications between the two nations, universal translators are often used. This large pendant houses one such device. However, it is becoming clear that some concepts can be humorously misinterpreted. *Breakfast*, *lunch*, *dinner* and *afternoon tea*, for example, are invariably all translated as "fish."

For this reason there are some who have decided to learn Cetacean the hard way. Professor Higgins has complied an extensive library of waxed disks, with every possible pronunciation of each whir and click represented. His assistant, Miss H. Jones, is working on a comprehensive dictionary she hopes will be useful to those traveling and working with Cetaceans.

SUPPLIES

35MM FILIGREE PIECE (I used a Vintaj Violet Petal)

Circular watch part (mine is 7/8" [2CM])

0.4MM SILVER PLATED WIRE (PATINATED)

Stone (real or faux) donut (mine has a 2 1/4" [5.5CM] outer diameter, with a 1 1/4" [3CM] hole)

Filigree adornment (I used a Vintaj Asian Marine Dolphin)

13" (33CM) piece of 1/2" (1.5CM) wide black velvet ribbon

2 1/2" (6.5CM) wide silver ribbon crimps (patinated)

2" (5CM) length of heavy silver chain (patina)

5MM crystal bead

Silver headpin (patina)

Silver Lobster clasp (patina)

5MM jump ring (patina)

EQUIPMENT

Nylon-jaw pliers

Needle-nose pliers

Wire cutters

Round-nose pliers

Jewelry glue (optional)

INQUIRE WITHIN

Create alternative themes by using other filigree animal shapes and color ways. Try suspending the pendant from a heavy chain or string of pearls for a different look.

Step 1 Using the nylon-jaw pliers, firmly work your way around the brass flower shape, squeezing the filigree flat. Place the watch piece in the center. Use the flat-nose pliers to gently but firmly curve the filigree around the watch piece. Keep it symmetrical by working on opposite sides in turn.

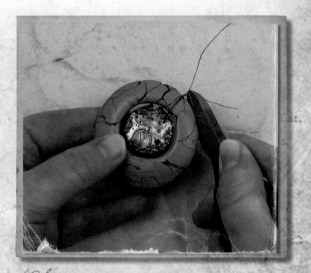

Step 2 Cut a 10" (25.5cm) length of 0.4mm wire. Thread the wire through a hole in either the watch part or the filigree. (It doesn't matter which; there should be plenty of small holes to choose from.) Place the filigreed bit inside the stone donut hole and wrap the wire around its outside. Repeat this 3 or 4 times, threading the wire through different holes of the filigree.

Step 3 Secure the short end of the wire by wrapping it a couple times around the long piece. Trim off the excess short wire.

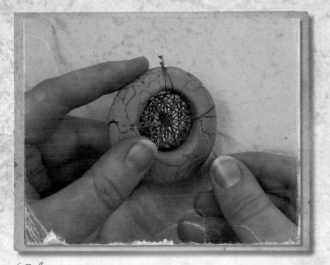

INQUIRE WITHIN

If you can't find a donut with a suitably sized hole for your watch, why not try making one? Mine is created from a slab of polymer clay using a faux-stone technique to make it look like turquoise. The circles were made with cookie cutters.

Step 4 Using the remaining wire tail, make a wrapped loop at the top of the donut (see Wrapped Loop on page 113).

 Cut another length of wire and secure a side of the watch to the stone. Keep the wraps tight and tidy. To finish off the wire, twist the strands together at the back of the piece and then trim the ends to about ¼" (6mm). Use the needle-nose pliers to tuck the wire inside the piece, where it won't scratch the wearer. Secure the other side of the piece in the same way.

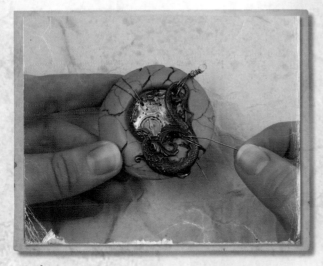

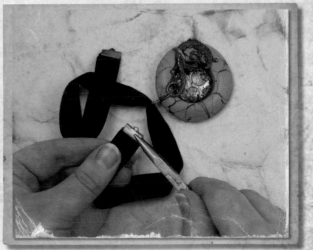

Step 5 To attach the dolphin, first hold it up to the pendant and see where it will sit most artistically and elegantly. If necessary, use the nylon-jaw pliers to bend the dolphin so it fits perfectly. (I folded the fin on mine to loop around the side of the stone.) Attach the dolphin by threading wire through the dolphin and around the stone a few times. Finish by twisting as before. Attach in at least 2 places to hold it firmly in place.

Step 6 Thread the ribbon through the pendant's loop, arranging the ribbon so the pendant will sit nicely. Use the ribbon crimps to secure the ribbon (see Ribbon Ends on page 115). If needed, use the jewelry glue to help secure the ribbon ends.

 Attach a 2" (5cm) length of the heavy silver chain to one side of the necklace end. Make a crystal dangle, attaching it to the end of the chain (see Making a Loop on page 112) with a crystal on a headpin dangle. Attach a lobster clasp to the remaining necklace end using a jump ring (see Opening and Closing a Jump Ring on page 114).

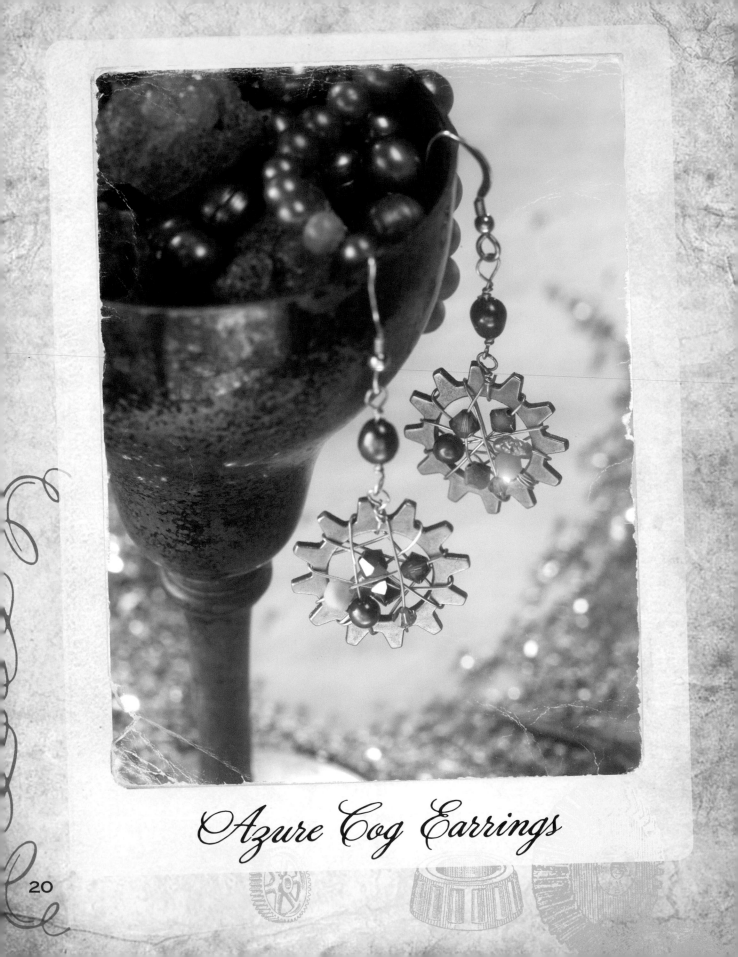

Azure Cog Earrings

ATLANTEAN SOCIETY IS FAMED FOR ITS INTRICATE JEWELRY PIECES. It is extraordinary how many exquisite items have emerged into the upper world over the years. Might the Nautilus at some point have discovered a secret horde of Atlantean treasure?

These fine gems have certainly appeared in ports where there are claimed sightings of the Nautilus, although links to its captain have never been proven. These beautiful earrings, for example, were given to the daughter of an impoverished Greek fisherman. She later married an officer stationed on Neptune and is blissfully happy in a little cottage made of shells.

SUPPLIES

0.4MM SILVER PLATED WIRE

2 COGS (I used some from TIM HOLTZ'S IDEA-OLOGY range; you will need 2 packs to get a matching pair)

8MM × 4MM CRYSTALS (I used MONTANA, metallic blue, jet AB and mint opaque)

2MM × 3MM CRYSTALS (LIGHT SAPPHIRE)

2MM × 4MM PEARL BEADS (TAHITIAN)

2 LARGE IRIDESCENT BLUE/BLACK PEARLS

2 SILVER EARRING HOOKS

EQUIPMENT

WIRE CUTTERS

ROUND-NOSE PLIERS

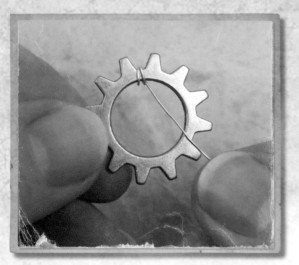

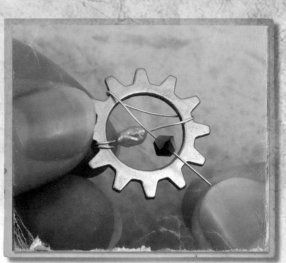

Step 1　Cut a 12" (30.5cm) length of the silver wire. Secure it to the cog by wrapping one end tightly around the cog's edge. Trim the short end off with wire cutters if necessary. (If you have a different style of cog, you can secure the wire by wrapping around the whole cog, slipping the wire between the gear teeth.)

Step 2　Thread 2 beads onto the wire. Wrap the wire around the cog, moving the beads as needed to place them at the front of the design. As you wrap the wire, work your way around the cog to make a pretty lattice.

Thread on the rest of the beads and arrange them in the center of the cog, adding one each time you wrap.

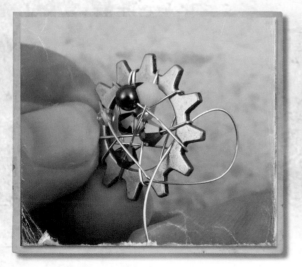

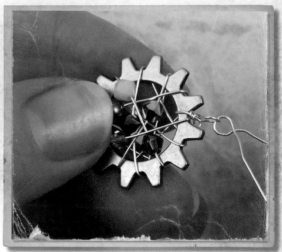

Step 3　When all the beads are added, loop the wire tightly around the top of the cog to finish and make a stable base for a wrapped loop.

Step 4　Create a wrapped loop with the wire tail (see Wrapped Loop on page 113) and trim the end neatly with wire cutters.

Cut a length of wire about 5" (12.5cm) long. Make a loop with the round-nose pliers at the end of the wire, and slip the wire through the wrapped loop at the top of the cog. Create a wrapped loop with the new wire, but do not trim the excess.

INQUIRE WITHIN

I use sterling silver ear hooks as they suit those who are allergic or sensitive to many metals. You can use the type you like best.

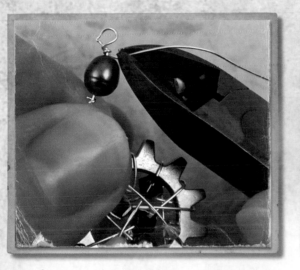

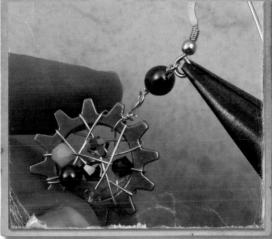

Step 5 Thread the large pearl onto the new piece of wire and make a wrapped loop at the top. Carefully trim any wire ends that are sticking out.

Step 6 Attach the earring hooks to the pearl section by twisting the loop at the bottom of the finding open and shut like a jump ring (see Opening and Closing a Jump Ring on page 114).

INQUIRE WITHIN

I like to use wrapped loops rather than plain ones because they are more secure. You can practice getting a neat wrap with the scrap bits of wire.

Mermaid Song Bracelet

NO ONE WHO HAS HEARD THE SIREN SONG OF THE MERMAID CAN EVER FORGET IT.
A sweet lullaby seeping across the waves, it has been known to drive men mad and wreck ships. But now some spectacular attempts have been made to save our ships from this natural disaster, most notably by the East India Shipping Company.

They have funded extensive research into neutralizing the song. One experiment involved recording the noise onto a wax cylinder and then playing back the exact opposite frequency, thus counteracting each noise. But most success has been had by finding objects that resonated at similar harmonics, creating a small force field around the individual. It is to this last group that this elegant bracelet belongs.

It has been field-tested extensively by the Petrides expedition, which also collected a large number of objects from the sea floor with similar resonating properties; they have generously donated these to the research department on Ulysses Three.

SUPPLIES

30G slow-dry Art Clay Silver 650

Small watch pieces and cogs (optional)

Liver of sulphur (optional)

0.4mm silver plated wire (patinated if you like)

4 similar-sized pieces of sea glass, approximately ½" (1.5cm) long

2 twisted cog disks in white bronze (from Objects and Elements)

4 5mm oval white pearls

2 4mm pale blue rice crispy pearls

20 5mm silver jump rings (patinated if you like)

20 4mm silver jump rings (patinated if you like)

2 ¾" × ½" (7cm × 1.5cm) 3-to-1 necklace connectors

4 silver shell charms

EQUIPMENT

6 playing cards

Sticky tape or glue

Wax paper

Acrylic roller

Rubber stamp (small intricate patterns work best; I used "Ink and the Dog" clock stamp C2)

Tissue blade

Cocktail stick

Needle files

Fine sandpaper

Blowtorch or kiln for firing silver clay

Wire brush

Sanding pads

Wire cutters

Round-nose pliers

INQUIRE WITHIN

Playing cards aren't just for a rousing game of whist! They can help you roll out the clay to an even thickness without employing rulers or other measuring devices.

If the clay is a bit sticky, rub the surface with a tiny bit of Badger Balm or olive oil as a release agent before stamping.

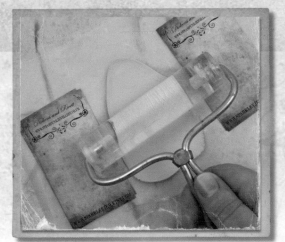

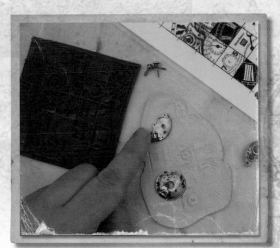

Step 1 Make 2 stacks of 3 cards each, securing the cards together with glue or sticky tape. On the wax paper, place the stacks about 3" (7cm) apart. Place the clay between the stacks and roll it out, resting the sides of the roller on the playing cards. (The clay will dry out fast, so work swiftly, and make sure you have room to cut three 1½" × ¾" [4cm × 2cm] rectangles.)

Step 2 Stamp the clay with the rubber stamp; you need to impress the design firmly. You can further embellish the clay by pressing small watch pieces and cogs into it.

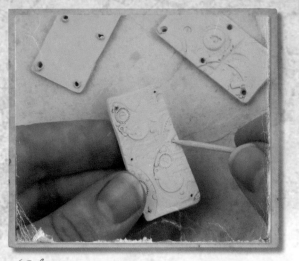

Step 3 Using the tissue blade, cut out three 1½" × ¾" (4cm × 2cm) rectangles. Use the cocktail stick to make 6 holes in each piece, 3 holes on each side. Make the holes larger than the 5mm jump rings, as the clay can shrink up to 25 percent during firing; the width of the cocktail stick is usually sufficient.

 Set the clay pieces aside to dry overnight.

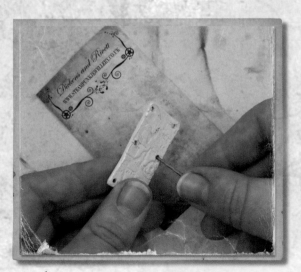

Step 4 Neaten the rough edges and holes in the clay by rubbing with needle files and sandpaper. Take care with the dry clay; it seems hard but is quite brittle.

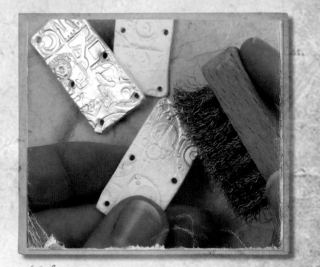

Step 5 Fire the clay according to the manufacturer's instructions. Make sure you use the appropriate method for your type of clay. Some clays need a kiln, and others can be fired by a blowtorch.

 After cooling, rub off all the white clay deposit with a wire brush to reveal the silver underneath. Polish thoroughly using either sanding pads or a jewelry tumbler filled with steel shot.

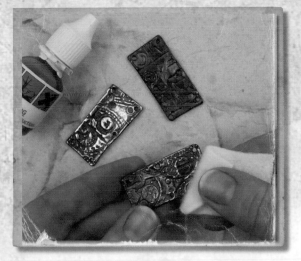

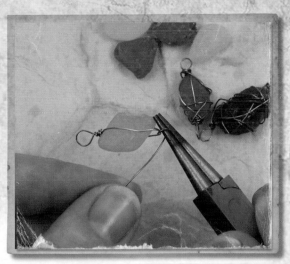

Step 6 To show the design in greater detail, you can patina it, if desired, with the liver of sulphur. Please observe all the manufacturer's safety precautions and instructions.

Step 7 Cut a 12" (30.5cm) piece of 0.4mm wire. Create a wrapped loop at one end (see Wrapped Loop on page 113). Hold the sea glass close to the loop and wrap the wire around it once. Secure by wrapping around the loop once, and continue around the sea glass to the opposite end. Make another wrapped loop there, and continue to wrap the whole piece in wire both vertically and horizontally, using the loops as securing points. Repeat with all the sea-glass pieces.

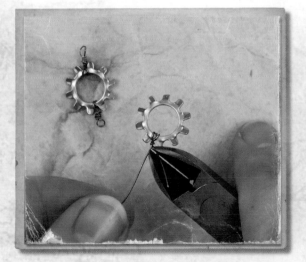

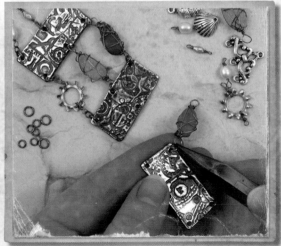

Step 8 Cut a 6" (15cm) piece of wire and wrap one end very tightly around the edge of a twisted cog. Wrap the small end around the long wire to finish. Create a wrapped loop with the long end. Keep it small and neat, and trim any excess wire. Do this on each side of each cog.

Create wrapped loops on either side of the 6 pearls, making 6 separate components.

Step 9 Use the jump rings to assemble the bracelet. Depending on the length of different components, you may have to add extra jump rings to make the shorter pieces match the longer ones. You can see I added extra jump rings next to my white pearls, and also next to the cogs, to make them the same length as the sea glass. Finally, attach a clasp and the shell charms with jump rings, too.

Abernethy 29. High St. Belfast.

Zeppelin Pirate Attack!

—◈—

MY DEAR MAJOR,

I am most sorry to have missed the ambassador's costume party, especially considering your dramatic unmasking of Andromeda Darkstorm. I believe she is now wanted for piracy in eight galaxies, and I can only imagine your disappointment when the Admiral's brig proved an ineffective prison.

I recollect well the day I first met Captain Darkstorm and experienced firsthand life aboard The Comet. I was a paying guest aboard a trading vessel commanded by Captain O'Brian high above Mars when The Comet was spotted, her skull and crossbones large upon her bow. We played hide and seek around Deimos for a while before she crept upon us and swept all before her with a crushing broadside.

I must admit I found Andromeda rather good company—she plays chess exceedingly well and told me many thrilling tales of her daring escapes—and her crew adores her, which I always feel must count for something. So I beg you, do not be too upset at your lack of prisoner, but pop over for dinner Thursday next and admire the enormous diamond she gave me upon receiving my ransom.

CHIN CHIN,

Emilly Ladybird

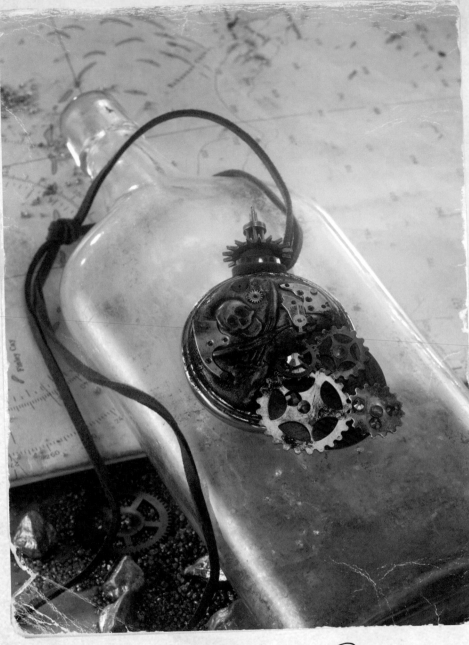

Storm Bringer Device

THE AETHER WINDS CAN BE TRICKY PATHS TO ROAM ON, and only a few have mastered the art of monitoring all the complex temperature and speed changes. Deadlier than any weapon, the *Storm Bringer Device* has allowed The Comet to prey on vessels across the galaxy and beyond.

A merchant's worst nightmare is to see Captain Andromeda Darkstorm standing fearlessly upon the deck, checking and aligning the pieces of the device. Then, with a swirl of aetheric energy, The Comet bears down on her quarry faster than could ever have been thought possible.

The laughing Andromeda swings between the ships, sword in one hand, cutlass in the other, a striking figure in her tight leather breeches and corset. Captains usually surrender their vessel within minutes; some have even proposed marriage at the same time.

SUPPLIES

3 COGS WHOSE GEARS INTERLOCK PERFECTLY (MINE ARE FROM RINGS & THINGS; ONE IS SIZED 1" [2.5CM] AND TWO ARE ¹/₂" [1.5CM])

ROUND BRASS BACK PLATE (MINE IS APPROXIMATELY 1¹/₄" [3CM] AND IS A VINTAJ ALTERED BLANK)

3 NAIL-HEAD RIVETS

POCKET WATCH CASE (JUST THE FRAME AND BACK PLATE, OR JUST THE FRAME)

BLACK POLYMER CLAY

GOLD POWDER OR ACRYLIC PAINT

ASSORTED VINTAGE WATCH PARTS (INCLUDING TINY COGS AND SCREWS, 2 BRIDGES FROM A WRISTWATCH AND A LARGE CLOCK'S COG AND SPINDLE)

5 ASSORTED FLAT-BACKED CRYSTALS (I USED 3MM × 3MM, 1MM × 4MM AND 1MM × 5MM)

ALCOHOL INKS AND FERRO RUST PAINT FOR DISTRESSING

EQUIPMENT

ADHESIVE PUTTY (OPTIONAL)

PENCIL

METAL HOLE PUNCH OR DRILL BIT THE SAME SIZE AS THE RIVET STEMS

NEEDLE FILE

WIRE-CUTTING PLIERS

FLAT FILE

RIVET-SETTING HAMMER AND STEEL BENCH BLOCK

MODELING OR SCULPTING TOOLS

RUBBER STAMP (I USED A PIRATE FLAG BOUGHT ON ETSY)

TISSUE BLADE

PAINTBRUSH

TWEEZERS

2-PART EPOXY GLUE

SMALL PLASTIC OR PAPER CUPS

COCKTAIL STICK

INQUIRE WITHIN

You don't have to use three cogs. You could go for two large ones or four small ones; just make sure they all interlock perfectly.

The more accurate the marking, riveting and interlocking of the cogs, the better these pieces will move. It will take practice to set your rivets to a perfect tension.

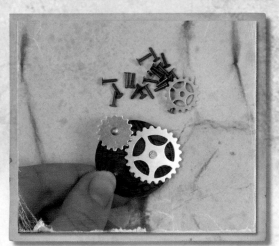

Step 1 Lay the cogs onto the brass blank. Make sure there will be an area at the top of the disk that can be inserted into the clay without interfering with the gears. Hold the gears in place with a bit of adhesive putty if necessary while you mark through the center holes with a pencil.

Step 2 Drill or cut holes on these marks exactly the same size as the rivet stems. Use a needle file to neaten and enlarge the holes, if necessary. Place a cog on the plate over its corresponding hole and pass a rivet through the hole.

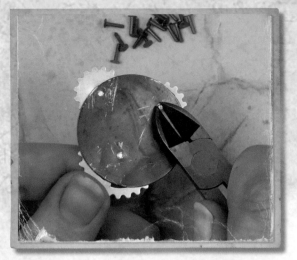

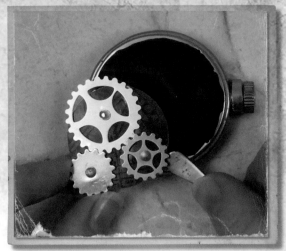

Step 3 On the back of the plate, snip the rivet stem off ¹⁄₁₆" (2mm) above the plate and file it smooth using the flat file. Set the rivet by gently tapping all around the edge of the stem to create a mushroom shape. Firmly hammer the back of the rivet until it is snug but the cog turns easily without wobbling up and down.

Repeat steps 2 and 3 to attach the remaining cogs.

Step 4 Pack the pocket-watch case or frame with conditioned black polymer clay (see Conditioning on page 116). Allow the clay to rise about ¼" (6mm) above the rim. Position the brass plate and press it down firmly, making sure all the cogs can still rotate freely. Use modeling tools to push clay away from any interfering areas; use a pencil or similar modeling tool to create a dimple in the clay under each rivet to avoid friction.

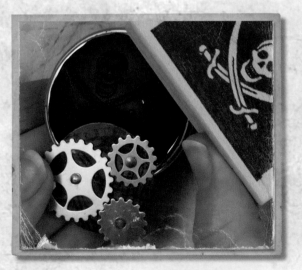

Step 5 Press the rubber stamp firmly onto the main area of clay. Use modeling tools to smooth and build up any areas distorted by the stamping.

Step 6 Slice the clay along the edge of the brass plate with the tissue blade and slide it under the Jolly Roger a little. Add tiny pieces of clay too to soften the edge line and help secure the brass plate. Make sure the cogs still turn, and remodel if necessary. Rub a tiny bit of gold powder gently over the raised areas with your finger; you need only a tiny bit. (Or, if you prefer, you can drybrush with gold acrylic paint after baking.)

Step 7 Add the small cogs and watch pieces and press them down firmly into the clay with a modeling tool or tweezers. Try to overlap and integrate them so they look as if they might actually work together. Think about what each component might do to give the illusion of a fully functioning device. Use tiny screws and the tops of headpins to imitate rivets.

Bake according to the clay manufacturer's instructions.

INQUIRE WITHIN

This stamp was perfect because the Jolly Roger ends up raised from the surrounding clay. If your stamp prints the other way (i.e., you would have a black skull and crossbones printed on paper), you might want to make a texture plate so the image is reversed.

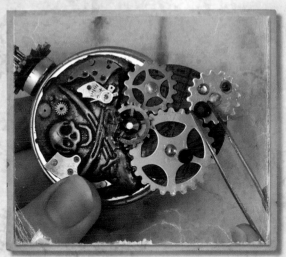

Step 8 Allow the piece to cool completely. Remove any loose watch parts or tiny cogs, but note their original placement.

Mix up some 2-part epoxy glue and use a cocktail stick to dab glue in the areas to reattach the pieces. Glue the crystals to the gears using tweezers; their placement should not impede cog movement.

Make sure the brass plate is firmly in place, and add some glue under that, if necessary, while avoiding the rivets. Allow the epoxy glue to set completely.

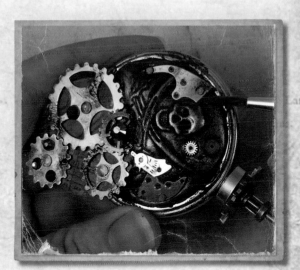

Step 9 Check that the riveted cogs still move freely, and adjust if necessary. Now is the time to make the two sections really look as if they are part of the same device. Distress the riveted cogs using alcohol inks, acrylic paint, StazOn ink or whatever you like, building up in layers. Add tiny splodges of Ferro rust texture along the edge of the case, the watch parts and the cogs, and work them into the piece with a brush (see Distressing and Coloring New Items on page 111).

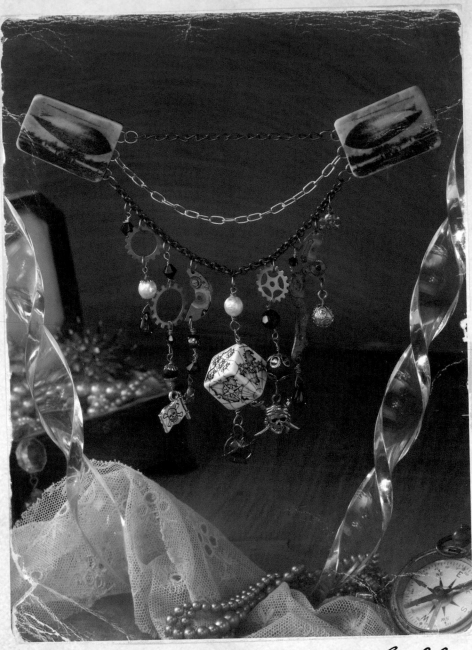

Zeppelin Pirate Necklace

WITH *OBJETS D'ART* GATHERED FROM ALL FAR CORNERS OF THE AETHER, this charming necklace can also be worn as a gypsy-style belt if attached to a waistcoat button. It is this style that has been adopted by admiring young debutantes across the empire after seeing Andromeda's picture in the color supplement of *The Times*.

Many outraged letters have been received by the editors as young girls started adopting tight trousers and wearing their pearls casually slung across the hip. The zeppelin depicted in the cameos is the ship in which Andromeda's parents were exploring, prior to their strange disappearance in the shipping lanes of the East India Trading Company. The young Andromeda was left in the guardianship of her Uncle Albert (later marooned by his own crew of cutthroats), which explains a lot.

SUPPLIES

1 BLACK-AND-WHITE IMAGE (I COPIED A VINTAGE ZEPPELIN POSTCARD 1" × 1^1/$_2$" [2.5CM × 4CM])

PEARL AND BLACK POLYMER CLAY

0.6MM BRASS WIRE

5 LENGTHS OF ASSORTED CHAIN, IN THE FOLLOWING LENGTHS: 3" (7.5CM), 4" (10CM), TWO 4^1/$_2$" (11.5CM) PIECES AND 5" (12.5CM)

0.4MM BRASS WIRE

ASSORTED CHARMS, BEADS AND VINTAGE PARTS; I USED:

 1 PIRATE DIE, HAND-DRILLED CORNER TO CORNER USING A JIG TO MAKE A BEAD (DICE FROM Q-WORKSHOP.COM)

 3 BRASS COGS (FROM RINGS & THINGS)

 2 VINTAGE BRASS WRISTWATCH HALF-MOON BRIDGES

 1 VINTAGE BRASS POCKET-WATCH BRIDGE

 5 ASSORTED PIRATE CHARMS (VINTAGE FINDS AND ASSORTED ETSY VENDORS)

13 ASSORTED BEADS, PEARLS AND CRYSTALS RANGING FROM 4MM TO 8MM

4 PAIRS OF FANCY BEAD CAPS

15 6MM BRASS JUMP RINGS

LOOP AND TOGGLE CLASP

ALCOHOL INK (OPTIONAL)

EQUIPMENT

INK-JET COPIER OR PRINTER

QUALITY COLORED PENCILS

PASTA MACHINE (FOR ROLLING OUT CLAY)

RULER

TISSUE BLADE

WIRE CUTTERS

ROUND-NOSE PLIERS

FLAT-NOSE PLIERS

SANDPAPER

Step 1 Make 2 black-and-white copies of the image using an ink-jet printer or copier. Flip the image so you have one right-facing and one left-facing design. To give that wonderful look of a vintage postcard, color in the image. You don't need to press hard with the pencils or color in neatly either.

Step 2 Condition and roll out the pearl clay to about ⅟₁₆" (2mm) thick (see Conditioning on page 116). Place the pictures facedown onto the clay. Burnish the images by rubbing firmly on the back of the paper with the edge of a ruler. Put a few drops of water onto the paper and let it soak in. Add a few more drops of water. When the paper is saturated, slowly begin rubbing the damp paper off the image with your finger, just a tiny bit at a time.

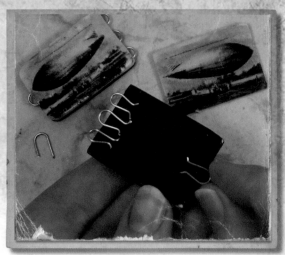

Step 3 Keep adding water and rubbing gently until all the damp white paper is gone, leaving the colored-in picture.

Trim the pearl clay with the tissue blade to neatly frame the image; my pieces are 1½" × 1" (4cm × 2.5cm).

Roll out the black clay to a similar thickness; lay the pictures down on top of it lightly. Don't press down—it's just a size guide. Trim the black clay to the same size and shape as the pearl clay pieces. Peel the black and pearl clay apart.

Step 4 Cut eight ½" (1.5cm) lengths of 0.6mm wire. Bend each piece into a U shape using the round-nose pliers. Bend a little kink on the end of each prong with flat-nose pliers. (This will stop them from pulling straight out of the baked clay.) Place the U-shaped wires onto the black clay, three on one short end, one on the opposite side. The loop will stick out 1⁄16" (2mm) from the edge of the clay. Layer the picture on top. The picture should face the right way into the necklace; you can always peel the layers apart and redo.

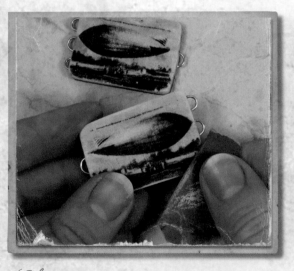

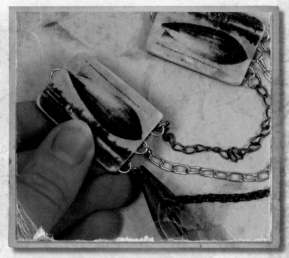

Step 5 Press the layers together firmly and trim any excess. Bake the spacers according to the clay manufacturer's instructions. When the pieces have thoroughly cooled, smooth the edges with very fine sandpaper. You can add distress around the corners as well to give them a worn look. Sand the back of the spacers in just one direction with very coarse paper to give a nice, heavily textured look.

Step 6 Attach the 3" (7.5cm), 4" (10cm) and 5" (12.5cm) chains to the spacer loops; the shortest length goes at the top of the spacer, and the longest goes at the bottom of the spacer.

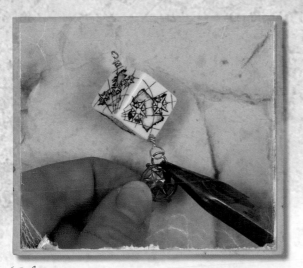

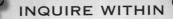

INQUIRE WITHIN

When attaching the chain, you can use jump rings if the chain is very fine or soldered closed. If the chain has a large, strong link, all you have to do is twist the last loop open, attach the link and close it just like a jump ring.

Step 7 Cut a 3" (7.5cm) length of 0.4mm wire and make a wrapped loop (see Wrapped Loop on page 113) on the top and bottom of your focal bead (mine is the drilled die). Attach a charm at the bottom of it with a jump ring.

Cut a 3" (7.5cm) length of the 0.4mm wire and make just the beginning of a wrapped loop. Thread this loop through the loop on the top of the focal bead and finish the wrap. Thread on a bead, and make another wrapped loop.

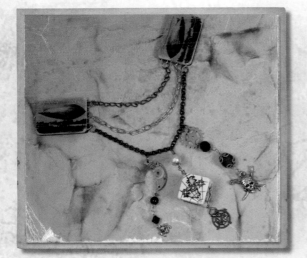

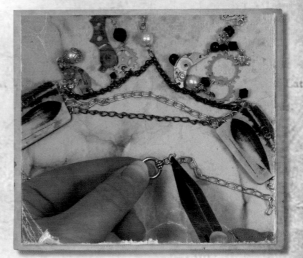

Step 8 Attach the dangle to the center of the long chain with a jump ring. Continue creating dangles using the assorted charms, beads and vintage parts and attaching them to the chain with jump rings. I made four 2½" (6.5cm) long dangles, two on each side of the focal bead, and two 1½" (4cm) dangles for each end side. Finish with just a charm or bead next to the spacer. Make sure as you attach them that you place the jump ring correctly in each chain loop; otherwise the dangle won't hang nicely.

Step 9 Attach the 4½" (4.5cm) lengths of chain to the back of the spacer, using either a jump ring or the chain itself. You can adjust these to make the necklace longer or shorter according to your personal taste. Attach the clasp to the other end of the chain in the same way. My finishing touch was to distress the die with a dab of alcohol ink on the corners to make it look suitably aged.

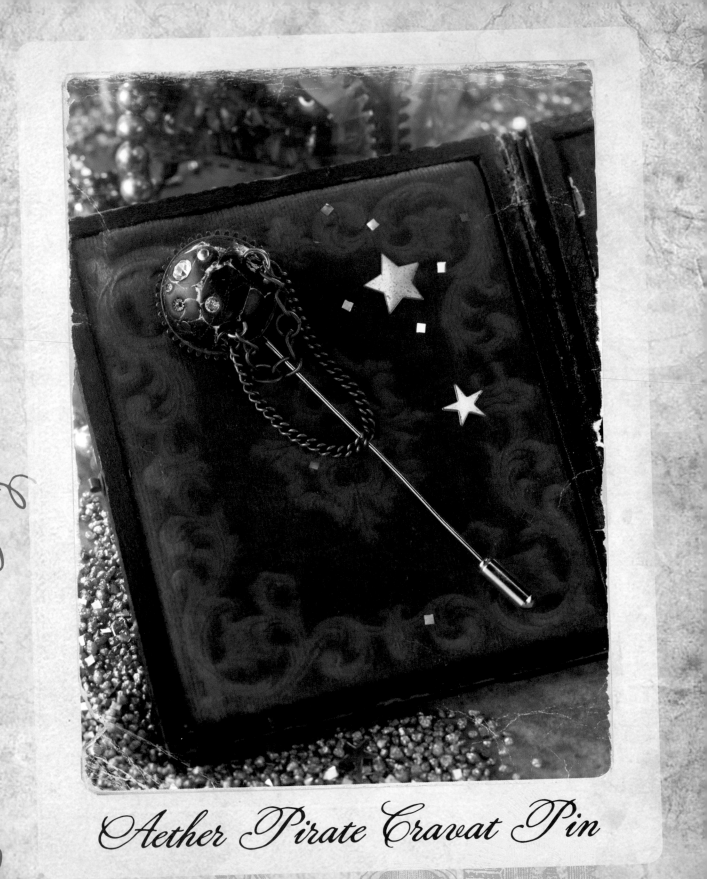

Aether Pirate Cravat Pin

THE MARBLE OF THIS PIN IS FOUND ONLY ON ONE OF THE MOST REMOTE PLANETS IN OUR SOLAR SYSTEM, TARPEIA. This marble's main property is that it is attracted to gold, almost as if magnetic. This caused much embarrassment when it simply refused to stick to the Ionian ambassador's present of gold and gems, intercepted—ahem—by Miss Darkstorm, en route to Buckingham Palace.

While it has become acceptable, in some circles, for a gentleman to wear a bow tie undone and casually draped around the neck, this should occur only after a hard evening of sparkling wit and elegant dancing. A cravat, however should never be worn so lightly. Elegantly tied in a bow of choice or simply knotted, it will always benefit from a beautiful pin to hold it smartly in place. Ladies, of course, have long known the advantages of carrying a pin about their person.

SUPPLIES

BLACK POLYMER CLAY, APPROXIMATELY $^1/_2$ OZ

WHITE ACRYLIC PAINT

SCRAP CLAY

2" (5CM) LONG STICKPIN

$^3/_4$" (2CM) MAINSPRING CASE (FROM A VINTAGE CLOCK) OR BEZEL

LIQUID POLYMER CLAY

2 CRYSTAL CHATONS, 3MM AND 4MM

3 OR 4 TINY SCREWS

3 OR 4 HEADPINS

2 5MM JUMP RINGS

2 LENGTHS OF ASSORTED CHAIN, 2" (5CM) AND 1" (2.5CM)

EQUIPMENT

PAINTBRUSH

WAX PAPER

TISSUE BLADE

CABOCHON MOLD (ROUGHLY THE SAME SIZE AS THE BEZEL)

WIRE CUTTERS

MODELING TOOL FOR SMOOTHING

GLUE

CLOTH FOR POLISHING

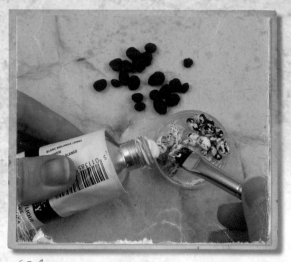

Step 1 Condition the polymer clay (see Conditioning on page 116) and break it into roughly pea-sized pieces; some should be large, some small. Roll them between your fingers to create pellets. Completely coat them with the white acrylic paint and spread them out to dry on a piece of wax paper. Wait until the paint is completely set and then squash them all together. Don't squash too hard; you need a few air gaps for a realistic effect.

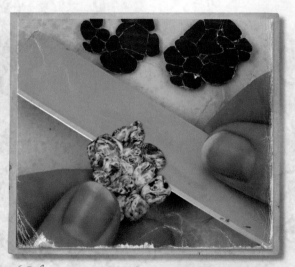

Step 2 After the pellets are all sticking together, form them into a rough rectangle and allow the clay to become firm again. With a fine tissue blade, cut ¹⁄₁₆" (2mm) thick slices from the rectangle. Be very careful, as the blade is extremely sharp. Look to see which slices give the nicest patterns. Remember that your slices will be double sided, so check both sides.

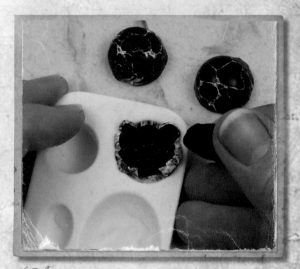

Step 3 Spray the mold with a light dusting of water to prevent sticking, and gently place a slice of clay, best side down, into the mold cup. Fill up the shape with scrap clay and level off the top, cutting off any excess with the tissue blade. Remove the clay from the mold; you can use a pin to ease it out if it sticks. Don't worry if your cabochon is not the exact size of the spring case or bezel at this point.

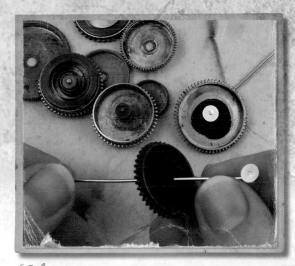

Step 4 Thread the stickpin through the hole in the spring case. (If you have a bezel with no hole but you'd still like the pin to spin, drill a small hole in the center of the bezel; then thread the stickpin through the hole.) Pack some polymer clay behind the head of the stickpin and also on top to within $\frac{1}{16}$" (2mm) of the top of the spring case or bezel edge. Bake the clay piece according to the manufacturer's instructions.

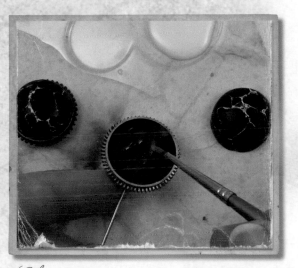

Step 5 When the piece is cool, use the paintbrush to apply a thin coat of liquid polymer clay to help the baked and unbaked clay stick. Place the cabochon into the bezel. Stroke the clay with a finger until it has a soft shine, removing any fingerprints.

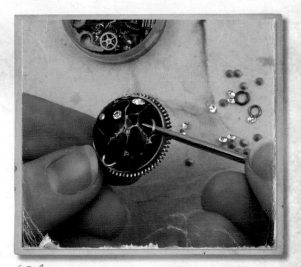

Step 6 Press the crystals, screws and headpins firmly in place. To make the rivets, use the wire cutters to snip the headpins off $\frac{1}{4}$" (6.5mm) from the top to make tiny rivet heads, and press them into the clay. Cut tiny slits for the jump rings toward the bottom of the cabochon. Insert the jump rings halfway into the clay, one in each slit. Use the modeling tool to gently roll the clay back over the jump rings, trapping them in place.

Bake the whole piece according to the manufacturer's instructions. When cool, attach the chains from the jump rings and glue the chatons in place, if necessary.

Gently rub the stickpin with a piece of cloth to polish it to a nice shine.

41

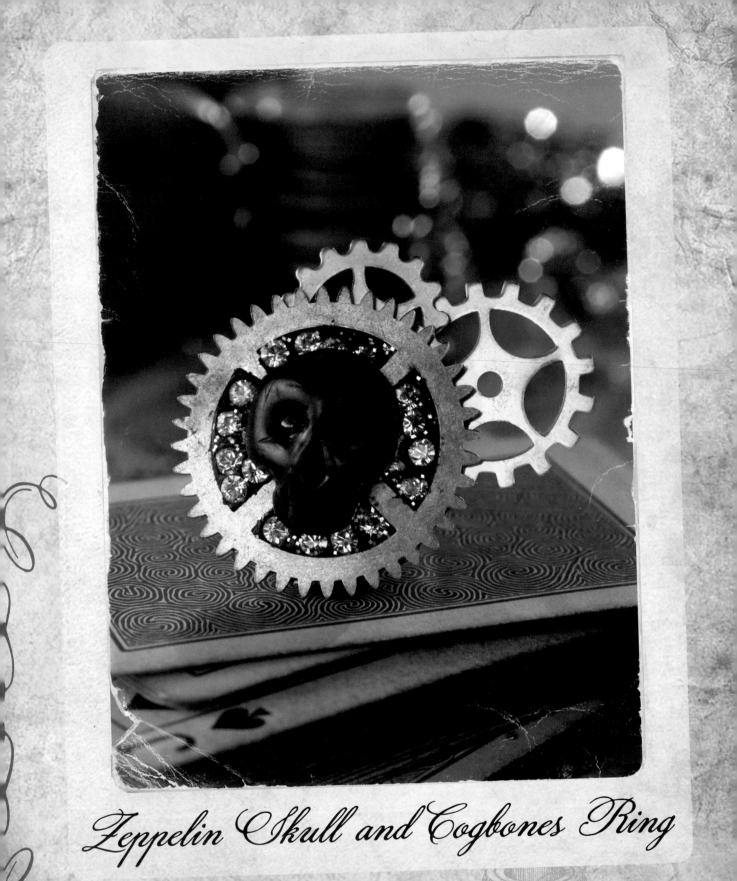

Zeppelin Skull and Cogbones Ring

ADMITTEDLY, THERE MAY BE PARAGONS OF TASTE AND DECENCY WHO FEEL THIS RING IS PERHAPS A LITTLE OSTENTATIOUS. Mr Dickens has been heard to call it "gauche." Mr Rivett thought it would never sell.

In that he was, of course, correct. It was never actually sold, although—after a daring raid on the heavily armored and vaulted aether ship *De Beers*—it was seen adorning the finger of Miss Darkstorm, that terror of interplanetary trade.

As it combines those two favorite piratical icons, the skull and the cogbones, it is not really surprising that it caught the eye of the daring buccaneer. Hopefully it will bring her more fortune than the previous owner—Dread Pirate Albert—who was marooned on Alpha Leonis ten years ago.

SUPPLIES

BLACK 2-PART EPOXY PASTE

2 3MM RUBY CHATONS

LARGE COG WITH 4 GAPS (MINE WAS 1" [2.5CM] IN DIAMETER)

SIMILAR SIZED COG WITH NO GAPS

CRYSTAL CHATONS (2MM OR 3MM)

GLITTER

2 SMALLER DECORATIVE COGS (MINE WERE ³⁄₄" [2CM] AND ¹⁄₂" [1.5CM])

RING BASE FINDING

EQUIPMENT

LATEX OR VINYL GLOVES

WAX PAPER

MODELING TOOLS

CRAFT KNIFE

TWEEZERS

PAINTBRUSH

2-PART EPOXY GLUE

SMALL PLASTIC OR PAPER CUPS

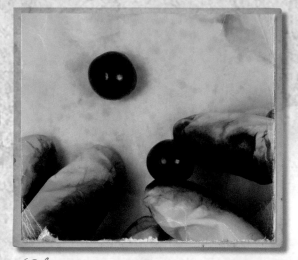

Step 1 Wearing vinyl or latex gloves, take a pea-sized piece of both the hardener and the resin epoxy and knead them together thoroughly for at least 4 minutes. Don't skimp on the blending; the paste will stay soft for about 20 minutes, so you'll have plenty of time to sculpt.

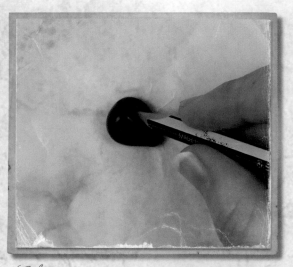

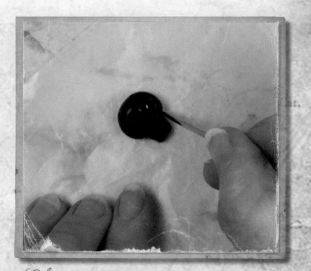

Step 2 When totally blended, and while still wearing the gloves, roll a piece into a ball the correct size for the central skull. This size depends on your central cog's diameter; my ball was about ½" (1.5cm) in each direction. Form this into a teardrop shape and place on some wax paper to flatten the underside.

Use a modeling tool or a pencil to poke depressions for the eyeholes.

Step 3 Place the ruby chatons deep in the holes created in step 2.

Using the modeling tools (my favorite is a big needle tool), press a triangular nose-shaped hole between the eye sockets. Press the edge of the teardrop shape in, on either side of the nose and under the eyes to create cheekbones. Finally, make dints for the teeth at the bottom of the teardrop.

Cut off the point to make a flattened jaw. Smooth and sculpt the skull until you are happy with it. Set it aside to harden.

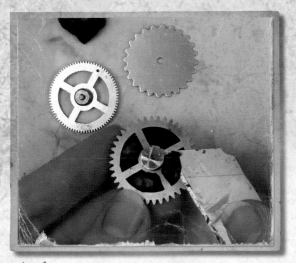

Step 4 Repeat step 1 to mix up more epoxy paste. Sandwich the epoxy paste between the top 4 hole cog and the bottom solid cog. Squeeze the two cogs together until there is only a 1-2mm gap between them. The epoxy paste will ooze up through the gaps, so trim it level with the sharp craft knife.

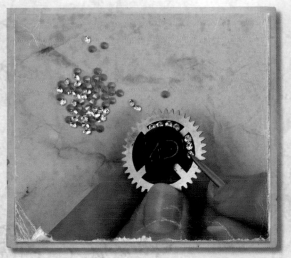

Step 5 Place the hardened skull onto the center of the ring and press the soft epoxy around its edges to hold it firmly when set. Using the tweezers, place the crystal chatons in the gaps of the cog and use one of your modeling tools to press them firmly into the paste. Use a paintbrush to dust glitter onto any gaps for a truly spectacular sparkle.

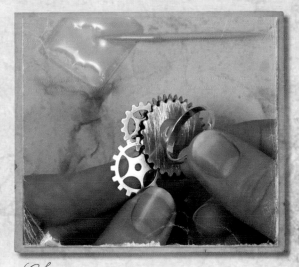

Step 6 Insert the two decorative cogs between the layers, wedging them into the epoxy paste. Press the chatons level, tidy any rough edges with the modeling tools and leave the ring to set completely.

Mix up some 2-part epoxy glue (or you could use the paste again) and fix the ring base to the back of the main cog. Make sure it is attached so the skull looks straight when the ring is being worn. Allow the epoxy to cure fully before you wear the ring.

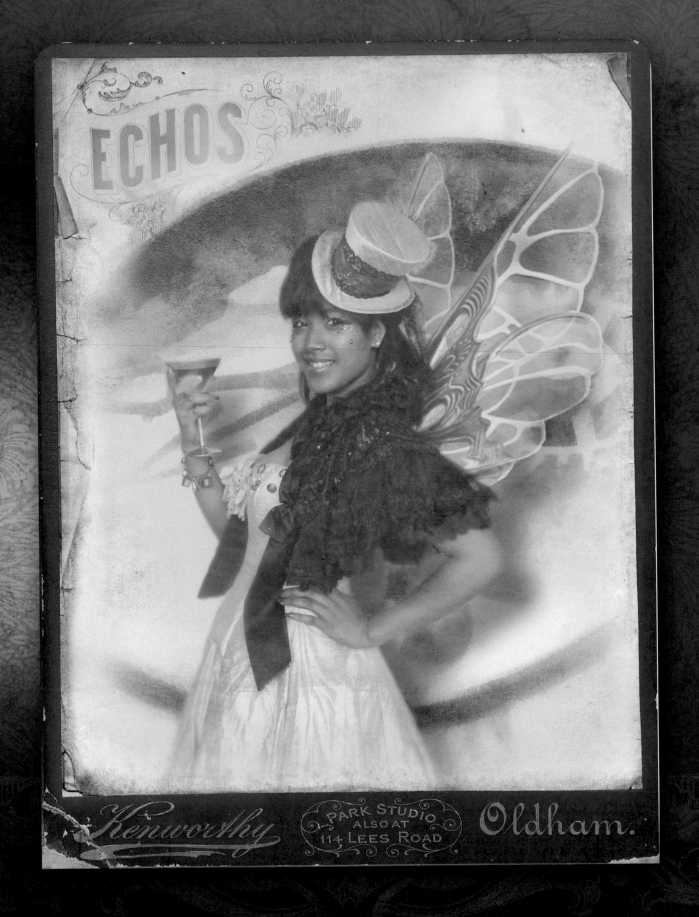

ECHOS

Kenworthy

PARK STUDIO
ALSO AT
114 LEES ROAD

Oldham.

Absinthe Fairy Interlude

---·◈·---

DEAREST MISS LIGHTFOOT,

You simply can't imagine how delightful Paris is in the springtime. Everyone is wearing their loveliest gowns and sitting outside little cafés watching the world go by. Absinthe is the drink of choice amongst the Bohemian set, although I am not sure its consumption is altogether wise. Several times, after drinking only a small glass, I have seen from the corner of my eye a shimmering, flittering figure in glittering green. However, every time I have tried to look at it directly, it has disappeared.

I discussed this apparition with my friend Lautrec. He was of the opinion that I had seen "the green fairy" and was insistent that I should describe her so he might paint her at last. With that in mind, I set out to construct a small and harmless trap using a mirror, a sugar lump, a jam jar and several green sequins.

To my joy, I managed to trap the little creature, and Lautrec was able to make a quick sketch before she bit him. He was delirious for days, but he did some of his best work. I greatly look forward to showing you the fairy pictures.

WITH LOVE,

Emilly

Brass Wings Necklace

A GLORIOUS ART NOUVEAU FANTASY, this beautiful necklace holds a drop of absinthe, triple distilled with fairy dust and totally poisonous to humans. It's rumored to be so potent that simply having it nearby will inspire continuous brilliant creative thoughts on art, poetry, music and dance.

Its owner, the wonderful Sarah Bernhardt, is considered to be living proof of its effect, although tests run by Dr Xavier Molyneux have proved rather inconclusive. While the output of the test subjects was certainly impressive, many notable critics were later heard to mutter, "Yes, yes, but is it art?"

The necklace itself was delivered in mysterious circumstances to the stage door of the theater where Miss Bernhardt was appearing. She had been expecting some fine jewels from Lalique and was surprised at how much the original design had altered. She went on stage to give the most outstanding performance of her career and only later found that the Lalique pieces had not yet been delivered.

SUPPLIES

2-PART EPOXY RESIN

OIL PAINT, YELLOW AND GREEN

OLD COG ABOUT 1" (2.5CM) ACROSS

MICRO GLITTER (I USED GLOW-IN-THE-DARK AND GREEN HOLOGRAPHIC)

TINY GLASS VIAL AND LID (I USED A WISH VIAL APPROXIMATELY 1" [2.5CM] IN LENGTH)

BRASS WINGS, RIGHT AND LEFT (I USED VINTAJ MYTHOLOGICAL WINGS)

METAL PAINT, LIME GREEN

ALCOHOL INK

FERRO PAINT, IRON

FILIGREE CENTERPIECE (I USED VINTAJ 38MM × 40MM NOVEAU CREST FILIGREE)

0.4MM ANTIQUED BRASS WIRE

FLAT-BACK CRYSTALS; I USED:

 3 4MM OLIVINE

 2 3MM JET AB

 1 6MM JET AB

3 6MM ANTIQUED COPPER JUMP RINGS

3 OVAL JUMP RINGS

2 9" (23CM) PIECES GREEN SILK RIBBON (MAKE LONGER OR SHORTER ACCORDING TO TASTE)

CLASP

2 ANTIQUED COPPER RIBBON ENDS

EQUIPMENT

COCKTAIL STICKS

SMALL PLASTIC OR PAPER CUPS

STICKY TAPE

BABY WIPES

CORNSTARCH

SMALL DRILL OR METAL PUNCH

NEEDLE FILE

PAINTBRUSH

SANDPAPER

WIRE CUTTERS

2-PART EPOXY GLUE

NEEDLE-NOSE PLIERS

INQUIRE WITHIN

Here's a handy trick for checking your cured resin: Keep the pot you mixed the resin in. When the residual resin is cured in the pot, it will be secured on your piece.

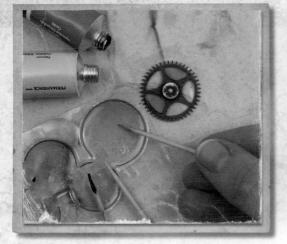

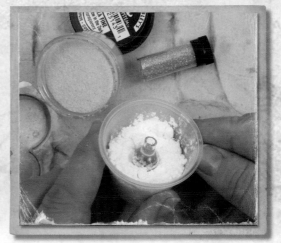

Step 1 Following the manufacturer's instructions, mix up a small amount of the 2-part epoxy resin (make at least the manufacturer's suggested minimum, or it might not set properly). Use cocktail sticks to add teeny amounts of oil paint, and blend well. Place your cog on a piece of sticky tape and make sure it has completely sealed each section. Using a clean cocktail stick, drop a tiny amount of resin in 2 of the cog compartments and allow it to spread.

Step 2 Mix a tiny bit of glitter with the remaining resin. Using a cocktail stick, drip the resin into the vial until it is half full. It helps if you tilt the vial while filling it. Clean off any resin on the outside with baby wipes. Stand the vial upright in the small bulb of cornstarch and allow the resin to dry and set. Resin can take up to 2 days to set—don't be impatient, or you might ruin it!

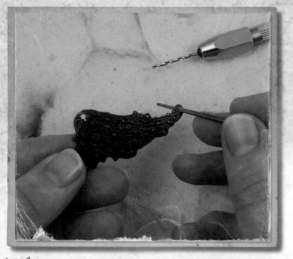

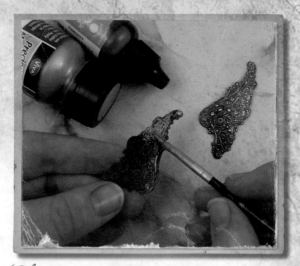

Step 3 Carefully drill holes in the tips of the brass wings with a small drill or metal punch. File the inside of the holes with the needle file to remove any sharp edges.

Step 4 Start painting with the metal paint; you don't need much paint, just enough to tint the wings. Cover about three–fourths of the wings' surface and make sure they match. While this paint is still wet, drop alcohol ink over the edges where the original brass shows through and blend the colors. Allow the wings to dry. When dry, gently rub them with the superfine sandpaper to expose the raised brass design.

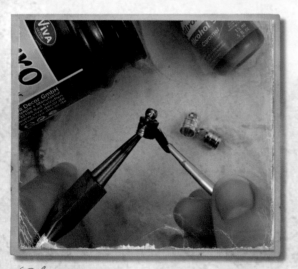

Step 5 While you are painting, you can distress the lid of the vial to match the rest of the piece. I used caramel alcohol ink first and then rubbed a bit of Ferro paint in Iron over it.

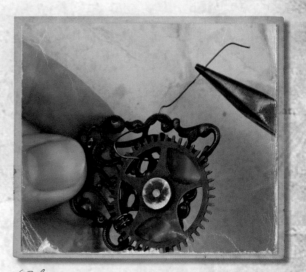

INQUIRE WITHIN

Be creative in your use of teeny vial: Consider a tiny test tube, a bead container or a mini light bulb! Make a wire loop for vials with cork lids.

Step 6 When your cog is completely set, peel off the sticky tape and place the cog on the filigree. Figure out where you will attach the two together. I attached my cog in two places, but your connection points will depend on your cog's design.

 Cut a length of 0.4mm wire. Tightly wrap the wire around the filigree at a connection point a few times to secure it. Then add the cog, wrapping the two pieces together. Trim the excess wire. Repeat this process at the remaining connection points.

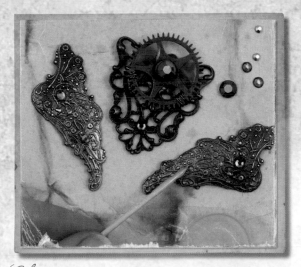

Step 7 Mix a small amount of 2-part epoxy glue. Using a cocktail stick, place tiny bits of glue on the metal, and then drop the crystals in place. Use a clean cocktail stick to press the crystals into the glue.

INQUIRE WITHIN

You could smother the piece with bling or stay fairly restrained. It's up to you. Hot-fix crystals won't stick to the painted metal properly, though, so you do need to use the proper glue.

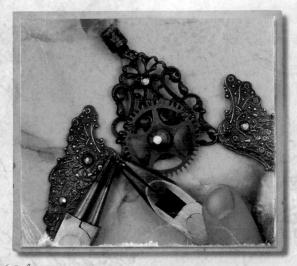

Step 8 Place a tiny bit of glue just at the top of the vial and attach the lid to the glass section. (If it won't close properly or pops off, there's too much glue, and the air can't escape.) Using the large jump rings, attach the wings to both sides of the filigree section and suspend the vial from the bottom. Place a jump ring at the tip of each wing as well.

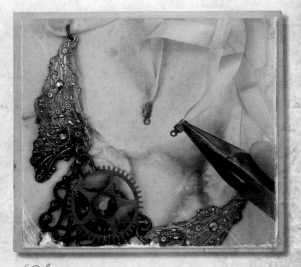

Step 9 Thread the silk through the jump ring at the tip of the wing. Double it over and encase both cut ends with the ribbon ends (see Ribbon Ends on page 115). You can add a spot of glue before using pliers to clamp the end shut for added security. Complete your necklace by fixing a clasp to the cord ends. (I used a spiraled hook and jump-ring combination.)

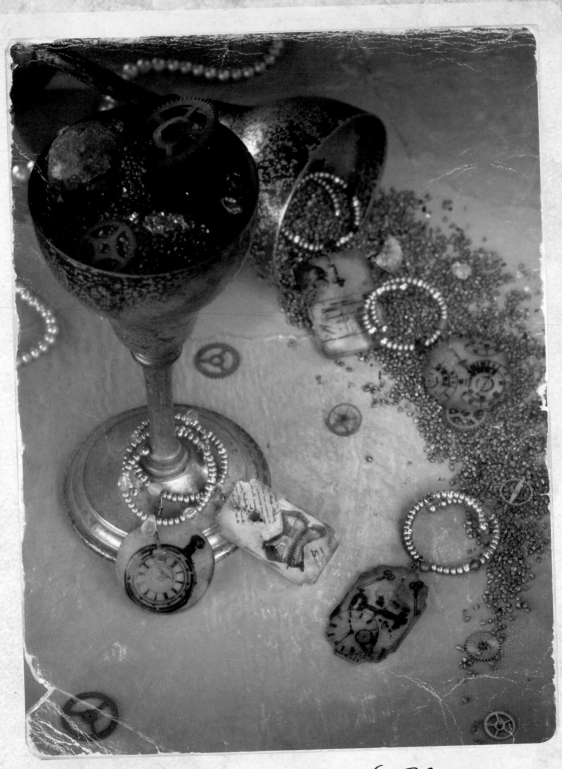

Absinthe Glass Charms

NO ONE CAN FORGET THE UNFORTUNATE INCIDENT OF LA BELLE OTERO AND THE LOVE POTION. It was the scandal of '86. Of course, had the hostess thought to provide her guests with these useful markers for their glasses, Miss Vinca Massini would never have drunk the love potion intended for The Crown Prince of Austria, leading to such ghastly consequences.

In the end it was all blamed on the meddling of The Green Fairy, although some rumors suggest she had entered the house only at the invitation of Otero, who wished to capture the attention of the prince. The effects did eventually wear off, and events certainly provided Miss Vinca Massini with one of the raciest chapters of her *Memoirs*.

SUPPLIES

1 A4 sheet of frosted shrink plastic

Alcohol ink, caramel and bright green

Alcohol ink blending solution

StazOn ink pad, timber brown

Lime green colored pencils

12 memory wire end caps

6 loops $1\frac{1}{2}$" (4cm) ring-sized memory wire

24" (61cm) piece of 0.4mm brass wire

Approximately 15g of size 15 seed beads

Approximately 30 4mm beads of assorted types, including bicone crystals, fire polished and rounds

EQUIPMENT

Scissors

Fancy scissors

Hole punch (I used Woodcrafts small key punch)

Blending pads or bits of felt/cloth

Rubber stamps (I used Clockplates from Ink and the Dog, and Corset and Postcard from Hampton Art)

Heat gun (or oven)

Wooden-ended needle tool

2-part epoxy glue

Small plastic or paper cups

Cocktail stick

Round-nose pliers

Wire cutters

INQUIRE WITHIN

*Different brands shrink
by different amounts
so shrink a test piece
to see if this size seems
right for your charms.*

Step 1 Using the regular scissors, cut out three
2" × 3" (5cm × 7.5cm) rectangles and three 3" (7.5cm)
diameter circles from the frosted shrink plastic.
Embellish the edges of the shapes with fancy scissors;
make each shape completely different. Use the hole
punch to make a hole to hang them with.

Step 2 On the rough side of the shrink-plastic
shapes, drip one drop of alcohol ink, rub it all over
and then rub nearly all of it off using the blending
solution and a bit of felt or cloth. There will be plenty
of color left, even though it looks like the merest tint.

Using the StazOn ink, stamp a different design on
the shiny side of each shape. Don't make the shapes
too complicated—they will end up one-fourth of this
original size. If you blur the image, just wipe off the
ink and start again. Allow the ink to dry. If you get
impatient, give it a quick blast with the heat gun, but
not enough to start the shrinking.

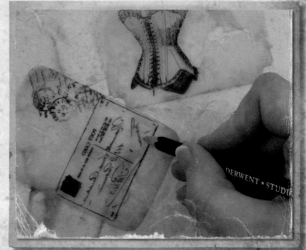

Step 3 When the ink is dry, turn each piece over
and color in the design further with the colored pencils
on the rough side of the shapes. The colors will intensify
when shrunk, so use a light touch.

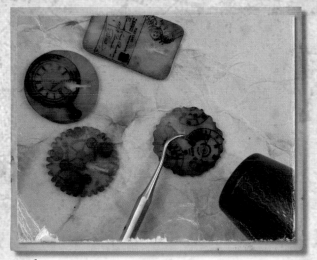

INQUIRE WITHIN

Step 5 is very fiddly, but it gives the charms a pretty, neat finish. The glue will dry clear, so don't worry if you can see a bit.

If you don't have any end caps or desire a different look, create a loop with round-nose pliers at one end of the memory wire to stop the beads from falling off. Leave enough room after stringing on the beads to turn another loop to secure the beads into place.

Step 4 Place the shapes on a nonflammable heatproof surface. Working one shape at a time, hold down the shape with a wooden-ended needle tool or something similar. Direct the heat gun at the shape to shrink the plastic. It will thrash about, curl and twist— don't worry, just keep heating until it is completely shrunk and flat. (You can also heat it in the oven according to the manufacturer's instructions.) Allow the shrunken plastic shapes to cool completely.

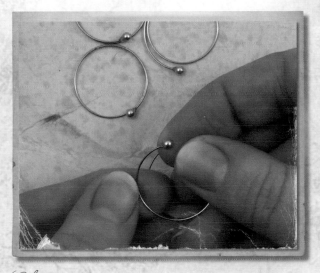

Step 5 Use the 2-part epoxy glue to adhere the memory wire end caps to one end of each ring piece. Use a cocktail stick to put a tiny drop of glue on the wire before threading on the cap. Leave it to dry.

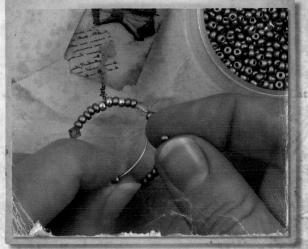

Step 6 Thread a piece of brass wire through each charm and twist the wire ends together a few times. Make a wrapped loop and trim the wire (see Wrapped Loop on page 113). Start threading on your seed beads and other small beads in a random pattern. When you get to the middle, thread on a charm. Continue with the seed and small beads to within ¼" (6mm) of the end. Glue on an end cap as in step 5; use the pliers to hold the pieces if your fingers get in the way.

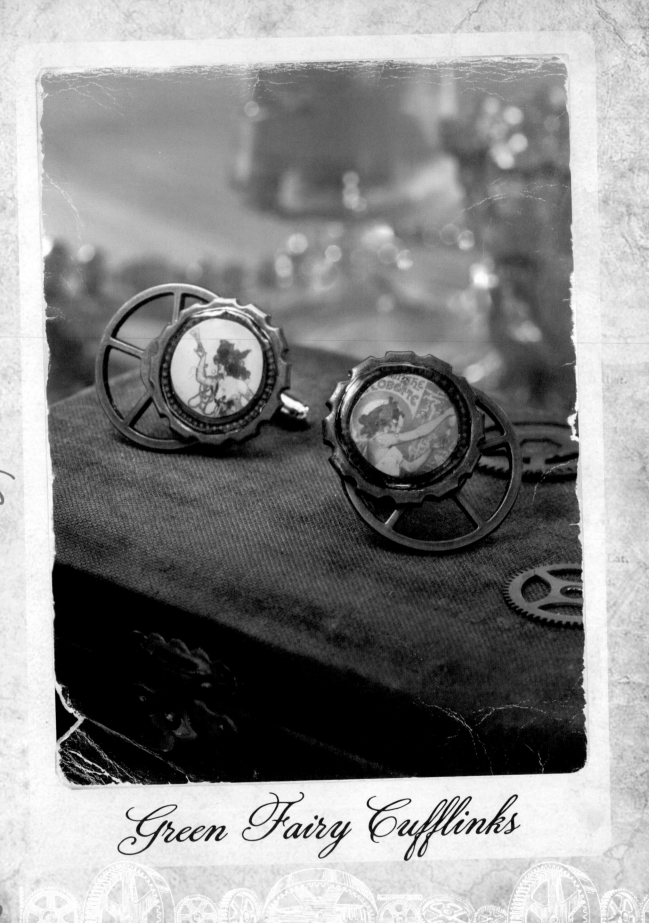

Green Fairy Cufflinks

THE USE OF AN EMBLEM AS ENTRANCE TO A SOCIETY OR CLUB HAS LONG BEEN *DE RIGUEUR* FOR THE SMART GENTLEMAN ABOUT TOWN. The most sought-after badge of entry is, of course, The Green Fairy. In cufflink or tie-pin form, this allows entry to that most exclusive of venues, the Verdigris Club.

From the exquisite balconies of the Art Nouveau mansion in which the club is housed, the sounds of laughter and earnest discussion pour forth. The lights of a hundred chandeliers sparkle as champagne is poured and inventions discussed. Beautiful ladies in stunning gowns assemble on the roof to view the night sky and discuss telescopes while dashing gentlemen play cards in the club lounge planning their next trip to Cassiopeia.

Membership is strictly by invitation, and it is of course a joy to see the egalitarian ideals of the French at the fore as luminaries such as M. Mesmer of the Academie Étoile Français and inventor M. de Villeroi rub shoulders with the Prince of Wales.

SUPPLIES

2 VINTAGE IMAGES

2 ¾" (2CM) ROUND BEZELS (I USED VINTAJ 22MM SPOKED GEAR)

GEL MEDIUM (I USED GOLDEN GEL GLOSSY MEDIUM)

GLOSSY ACCENTS (OR RESIN OF YOUR CHOICE)

2-PART EPOXY GLUE

2 1" (2.5CM) COGS (I USED A PAIR OF IDEA-OLOGY COGS AND GEARS)

2 CUFFLINK BACKS

EQUIPMENT

INK-JET PRINTER

SCISSORS

PAINTBRUSH

PLASTIC SHEET

SMALL PLASTIC OR PAPER CUPS

COCKTAIL STICK

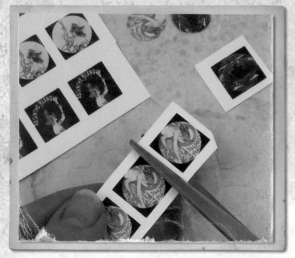

Step 1 If it's not already the correct size, you will need to adjust your vintage image to fit the bezel. You can use Photoshop or a similar program to shrink the images down; just remember to keep the image at a nice sharp resolution, and make sure it is copyright free. Print out the images and neatly cut them out.

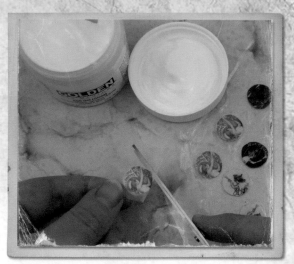

Step 2 Paint a thin layer of the gel medium onto the plastic sheet. Place the image on top of the gel, and paint on more gel. Make sure all the gel is completely dry before cutting the image from the plastic.

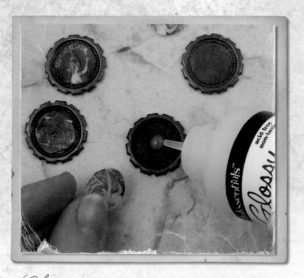

Step 3 Using the Glossy Accents, adhere the pictures, image side up, into the bezels.

INQUIRE WITHIN

Most inks will bleed if you just pour resin or similar products on them, creating a murky image or one that has transparent patches. To avoid this, I seal the pictures either with sticky tape on both sides or with a gloss gel medium. When you trim the images from the gel or sticky tape, make sure there is a tiny sealed border around them to avoid having the resin or Glossy Accents seep in around the edges.

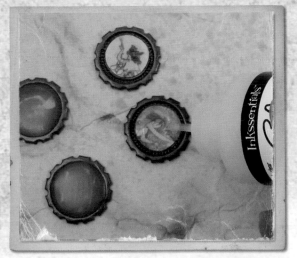

INQUIRE WITHIN

I like to use Glossy Accents with printed images because not all papers need sealing when used with Glossy Accents, but all do when sealed with resin. If you're using Glossy Accents, do a test on an extra piece of paper to check compatibility.

Step 4 Very slowly, squeeze a thick layer of the Glossy Accents into the bezel; keep the tip of the tube just touching the gel to avoid air bubbles. If you do get a bubble, prick it with a pin. Allow it to cure for 12 hours it is until clear. The combination of gel medium and Glossy Accents will fade an ink-jet print to a vintage hue. You could also use epoxy resin or UV resin on sealed paper for a slightly brighter look.

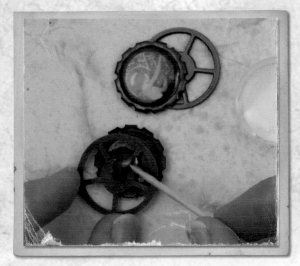

Step 5 Mix up some of the 2-part epoxy glue. Use a cocktail stick to apply the glue to the back of the bezel. Make sure you apply plenty of glue, but keep the glue surface flat, not mounded, so you can apply the cufflink shanks later. Attach the large cog to the back of the bezel. Applying the cog pieces separately to the cufflink shank gives you more control than trying to attach everything at once. Let the glue dry thoroughly.

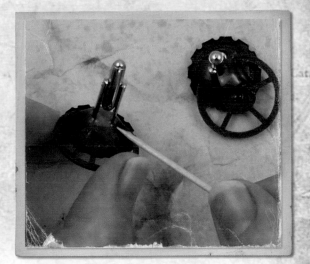

Step 6 Take a moment to work out which way up the pictures should be and how the cufflink shanks should attach so the image will look nicest in the cuff. Mix up another batch of epoxy glue and finally stick the cufflink shanks to the back of the pieces. Allow the glue to dry for at least 12 hours to gain its full strength.

Absinthe Fairy Charm Bracelet

FULL OF THE CHARMS OF *FIN DE SIÈCLE* PARIS, this gorgeous bracelet adorns the wrist of The Green Fairy herself. It is full of discarded and forgotten gems and trinkets, carelessly abandoned by the patrons of the Moulin Rouge; in glee, The Green Fairy flits hither and thither, collecting trophies and sparkles.

A tiny corset charm, given to one of the dancers by an admirer; emeralds and pearls from a necklace snapped in a passion by a diva; cogs from the watch of Jules Verne himself.

But the question those who see her would love to know the answer to is, *Whose portrait is kept in the teeny locket?* Is it also just a lost treasure, or does it show the secret love of the fairy herself?

SUPPLIES

Polymer clay, green, gold, black and cream, approximately 1oz of each

Filigree bead for wrapping (I used a Vintaj 14mm filigree bead)

20mm central faceted stone (I used a vintage olive-colored Czech crystal)

Jump rings or split rings

Approximately 6" (15cm) of chunky antique copper chain (lengthen or shorten to your own taste)

10 antiqued brass headpins to make dangles

0.4mm gold plated wire

Approximately 23 charms and beads in green, gold and brass; among my charms you will find:

 3 10mm green powdered pearl beads by Guttermann

 3 glass leaves

 3 5mm real pearls in acid yellow

 3 6mm emerald green faceted beads

2 vintage brass cogs

A bottle, Tinkerbell, padlock, brass heart, tiny corset, miniature vintage locket

A brass Art Nouveau fairy (from Vintaj)

A brass magnolia leaf-bead cap (from Vintaj)

Lobster clasp and split ring in antique copper

EQUIPMENT

Pasta machine (for conditioning and rolling out polymer clay)

Tissue blade

Needle tool

Small metal file

Nylon-jaw pliers

Chain-nose pliers

Wire cutters

Round-nose pliers

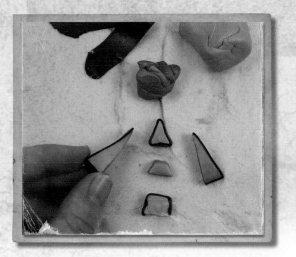

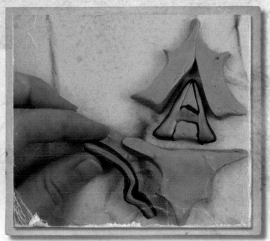

Step 1 To create your absinthe label beads, you first need to make a polymer clay cane. Condition the clay until it is pliable and smooth (see Conditioning on page 116). Roll out a piece of the black clay very thinly. Take about a fourth of the gold clay and a pinch of cream and make a triangle from the cream clay, surrounding it with a strip of the black. Follow the photograph to create the rest of the shapes needed to form the A.

Step 2 Push the shapes from step 1 together and surround the A with a fancy shield shape in cream clay. Roll a strip of gold about ¼" (6mm) thick and place a thin black stripe on each side. Wrap this completely around the shield shape. Press everything together firmly and make sure the shield shape is symmetrical. The shape should be about 1" (2.5cm) deep and 1½" (4cm) across.

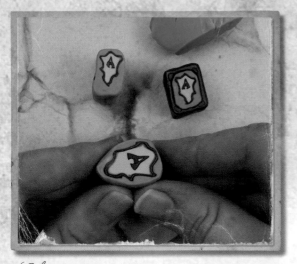

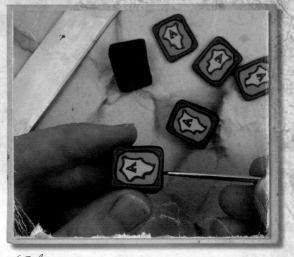

Step 3 Add pieces of green clay to fill in the gaps, shaping them to fill the shield curves exactly. Try to enclose the shield inside a green circle or oval. Gradually reduce the cane by gently pulling and squeezing to make a long, thin sausage shape about ½" (1.5cm) across. (Don't roll the clay, or the A will become distorted.) Create a square by flattening the sides, and add a border with the remaining gold and black clay. Leave the cane to become firm overnight.

Step 4 Using the tissue blade, cut complete ¼" (6mm) slabs from the cane. Pierce the center of the slab with a needle tool to create a hole, and bake it according to the manufacturer's instructions.

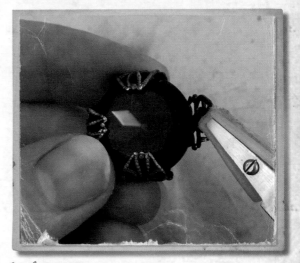

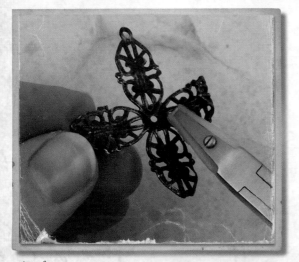

Step 6 Place the gemstone in the very center of the filigree. Using your fingers and round-nose pliers if you need to, curve one of the filigree arms over the gemstone. Don't clamp it down too hard yet. Make sure the gem is still in the center and then curve the opposite filigree arm over so the gem is held firmly in place. Finally, curve the remaining two pieces into place and press it all tight with nylon-jaw pliers.

Step 5 To create the filigree gem focal, first you need to open the filigree bead out. Pry it open gently and use the nylon-jaw pliers to flatten it completely into a cross shape. (You can use normal flat-nose pliers, too, but they could scratch the filigree.) Snip off the little loop at the top of one of the filigree arms and file it down to match the other 3 sides.

INQUIRE WITHIN

If you wish to be economical with your cane, cut 1mm slices and firmly place a slice on either side of a plain black rectangle. You can also texture the plain black edges by pressing rough sandpaper against them.

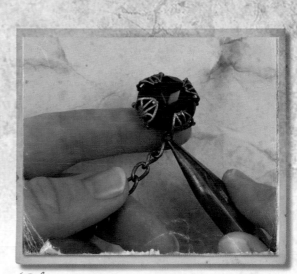

Step 7 Slip an open jump ring through a piece of the filigree and then through the last loop of the chain (see Opening and Closing a Jump Ring on page 114). Close it up tight. Attach a split ring to the filigree on the other side.

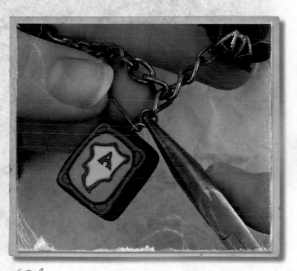

Step 8 Thread the absinthe-label beads onto headpins and attach them at regular intervals around the chain with a wrapped loop (see Wrapped Loop on page 113). Attach any other beads that need headpins in the same way.

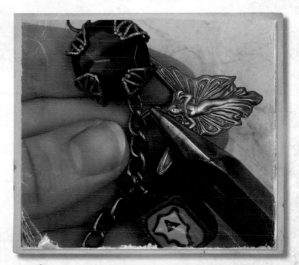

Step 9 You can use either jump rings or split rings to attach the charms. Some beads, like the leaves, may need to be attached with wire using wrapped loops. Attach one clasp piece to each end of the chain.

J. Barron

No. 4, DURAND BLO[...]
SARNIA, ON[...]

Jurassic Valley Exploration

—◈—

DEAR MR DICKENS,

The jungle grows ever thicker and more oppressive. At night the cries of distant unknown beasts fill the air. Lord Philip Barham is an exemplary expedition organizer, however, and well deserving of the Natural Science Institutes bursary. We have real hopes of entering the Jurassic valley again tomorrow. After dinner, served in candlelight by the admirable Jackson, we even attempted a few lively renditions of Gilbert and Sullivan numbers. We have nearly finished the brandy, however.

Pip told me all about his previous expedition when he first discovered the hidden valley, lost in an oasis of time. The rest of his party had long turned back, calling him insane. Yet still he followed the ancient glyphs, appearing at intervals through the jungle, which he believed to be signposts to somewhere wondrous. Exhausted and nearing starvation, he at last stumbled over a precipice—but instead of falling to his doom, he descended into a lake heated by thermal springs. All around, giant dragonflies whirred, and ancient fern species thrived. Herds of huge beasts, no longer seen in the civilized world, roamed freely.

This second expedition with film and camera equipment should prove most illuminating. I have also taken rubbings of all stelae we have encountered so far and hope to translate them upon our return.

VERY BEST WISHES,

Emilly

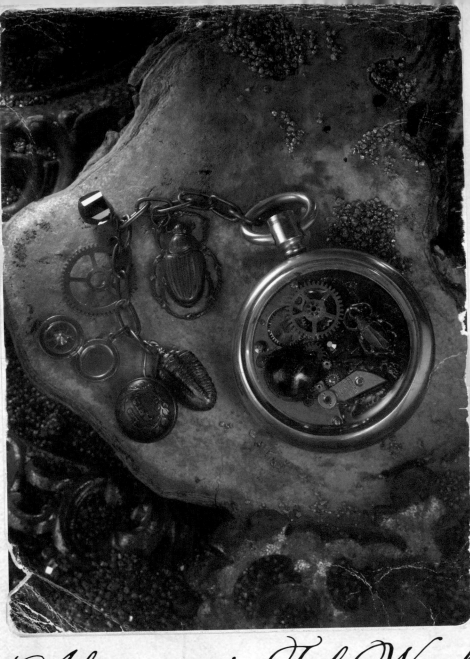

Adventurer's Fob Watch

IMPRINTS OF SKELETON LEAVES AND RAINBOWS DECORATE THIS STUNNING
PIECE, which belonged to the third Lord Barham. Followers of the adventuring family's exploits may
remember that Lord B disappeared in darkest Peru while attempting to find the source of the Ucayali.
This fob watch was discovered, with his field notes and several new species of beetle, in an empty canoe
drifting some miles down the Amazon.

There is a twin to the large rainbow gem, set into the bar at The Adventurer's Club, Mayfair. When
the two stones are in alignment, the watch vibrates, ensuring that the wearer can never be lost and will
always be able to return to the club in time for luncheon. This makes Lord Barham's disappearance all
the more mysterious.

His son, Philip, has mounted several expeditions to discover the truth, believing that his father may
have been captured and held prisoner by a lost civilization deep in the jungle.

SUPPLIES

Old watch

Polymer clay skinner blend

Powder pigments, iridescent and gold

Scrap clay

Liquid polymer clay for glazing

1oz polymer clay, green

5–6 3mm or 4mm crystal chatons

Acrylic paint, brown and black

Small fossil

0.4mm gold plated wire

1 dome button

4" (10cm) piece of large brass chain

Large brass jump ring

Tiny brass beetle charm (Vintaj)

Assorted charms and beads, all between ¹/₂" (1.5cm) and 1" (2.5cm)

EQUIPMENT

Watchmaker's screwdriver set

Tissue blade

Pasta machine (for conditioning and rolling clay)

Flat-nose pliers

Cabochon mold

Stamps (by See-D Morsels)

Tweezers

Cotton swab or sponge

2-part epoxy glue

Small plastic or paper cups

Bent-nose pliers

Step 1 First take apart your chosen watch (see Taking a Watch Apart on page 107). Using the watchmaker's screwdriver set, unscrew everything and set aside several pieces to be used later. You'll need some tiny cogs and little screws, too. If you've just got an empty watch case, collect some interesting cogs and metal plates from previous projects. Reassemble the case and unscrew the glass front or bevel (if your watch has lost its glass). If the glass is very scratched, you may want to remove or replace it.

Step 2 Take your skinner blend (see Skinner Blend on page 118) and roll it up tightly, matching colors, so you have a striped sausage shape. Gently compress it into a rectangle, pushing from each end with your fingers and thumbs. Cut a slice from it. If the blend isn't perfect, you can reblend it through the pasta machine if necessary. Roll it out to the right size to fit in the mold.

Step 3 Gently dust the cogs with iridescent powder and lay them, powder side down, on the rainbow slice. Tap the cog all over with the end of the pliers to make sure every bit of it has touched the clay. You don't need to squash the cogs in, just transfer the powder. (Experiment with scrap clay to see how much powder to use.) Remove the cogs, levering them off the clay with a pin if needed.

Step 4 Spray the cabochon mold with water. Place the mica-embellished rainbow slice, cog imprint side into the mold, and fill the rest of the space with a ball of scrap clay. Fold the edges in over the top and smooth the clay. Pull everything out of the mold, using a pin to loosen the clay if needed. Bake the cabochons according to the manufacturer's instructions. When cool, glaze the cabochons with the liquid clay (see Glazing on page 121).

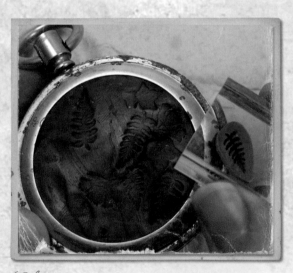

Step 5 Pack the inside of the watch case with the green polymer clay. Smooth the clay until it is level with the top edge. Check that the bevel or glass can still screws on. Stamp gently all over the clay. (I used tiny Jurassic-style ferns and leaves, but any detailed stamp will impart a good texture.)

INQUIRE WITHIN

Try spraying the surface of the clay with water if your stamps stick. You can overlap images, too. If you don't like your pattern, smooth the clay and start again.

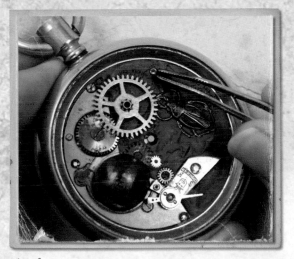

Step 6 Position the metal elements on the clay, trying not to cover up too much of the stamping. Use the tweezers to embed them into the clay; you can hollow out the clay beneath them if necessary. Place the tiny cogs and screws into the piece, replacing them in any original watch parts where you can. Finally, press in the crystal chatons for dewdrop sparkles. Bake the whole piece according to the clay manufacturer's instructions.

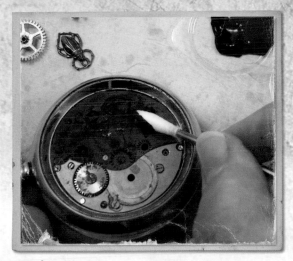

Step 7 When the watch has cooled, remove the small metal and crystal components. These will need to be glued in place after applying the patina. Rub brown and black paint well into the clay. Using a barely damp piece of sponge or cotton swab, wipe off the paint from the texture to highlight the stamped pattern. Glaze with liquid clay. When cool, glue the metal and crystal pieces back in place.

Step 8 To make a trilobite or fossil fob, first create a mold from your original piece (see How to Make Molds on page 117). Mist the mold with water and then press in black clay. Make 2 impressions and sandwich a piece of wire between them, using the liquid clay as glue. Using your finger, dust gold powder on the surface of the fossil to highlight the raised areas. Bake and glaze as before.

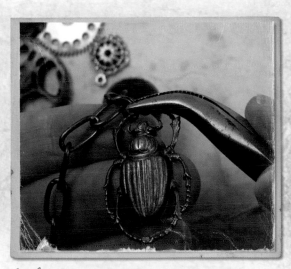

Step 9 Attach the button to one end of the chain using the bent-nose pliers (this will attach to your waistcoat buttonhole). Fix the other end of the chain to the watch, using the large jump ring if necessary. Hang the beads and charms from the chain using split rings or wrapped loops; try to get an interesting selection of dangles, appropriate to the theme of the watch. Replace the front bezel or glass.

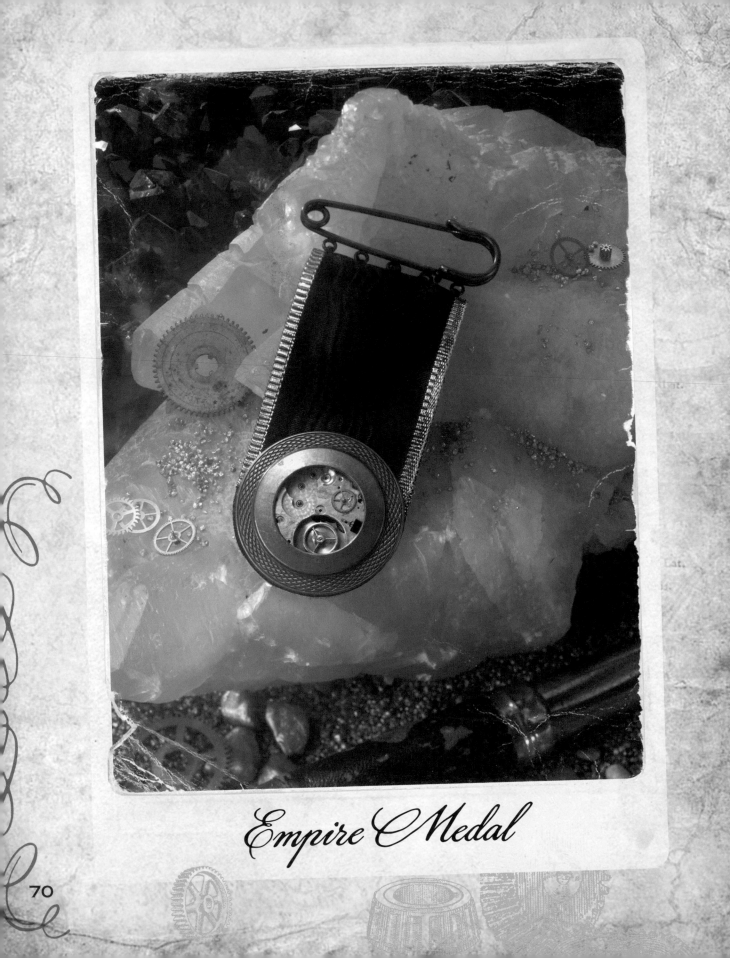

Empire Medal

AS THE HORDES OF TENTACLED AIR KRAKEN EMERGED FROM THEIR DAYTIME LAIR, hoping to feast on the delicious blood of princess Aspidistra of Vlacq, only one man stood in their path. Brandishing his Apogee 726 repeating pistol, Captain Pip Barham leapt into the midst of the monsters. Firing wildly left and right, he did not think them too many, slaughtering the cephalopods with careless abandon.

The King of Vlacq was suitably impressed, and it is only with great difficulty that the future Lord Barham extricated himself from the marriage arrangements and evaded pursuit by the lovesick and wilting Aspidistra.

Upon his return to Blighty, he was awarded The Empire Medal for services leading to greater harmony between the empire and alien nations, and also The Swift Cross for outrageous embellishment of exploits.

SUPPLIES

METAL DONUT AT LEAST ½" (1.5CM) LARGER THAN YOUR WATCH (I USED A VINTAJ BRASS DONUT AND A SCAVENGED ALUMINIUM DISK FROM THE INSIDE OF A COMPUTER)

A BROKEN WATCH AT LEAST ½" (1.5CM) LARGER THAN THE DONUT'S INSIDE HOLE

ALCOHOL INK

TAFFETA RIBBON THE WIDTH OF THE OUTSIDE OF YOUR DONUT (MINE IS 1½" [4CM])

KILT PIN (WITH OR WITHOUT HANGING LOOPS—MINE DOES HAVE THEM)

SMALL PIECE OF LEATHER, FELT OR ANY OTHER NONFRAYING FABRIC

EQUIPMENT

WOODEN SHAPING TOOL AND DAPPING BLOCK (OPTIONAL)

WATCHMAKER'S SCREWDRIVER

2-PART EPOXY GLUE

SMALL PLASTIC CUPS

COCKTAIL STICKS

SANDPAPER

SCISSORS

NEEDLE AND THREAD

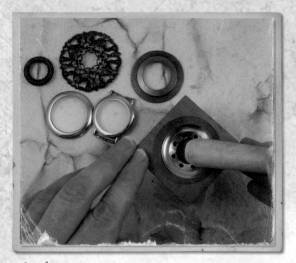

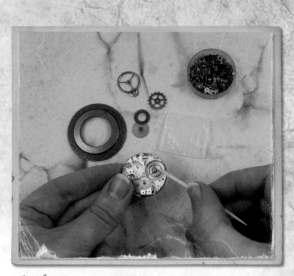

Step 1 If your donut is completely flat, you will need to put a slight curve into it. Place the metal piece into an appropriately sized depression in the dapping block, face down, and tap all around with the wooden shaping tool.

Step 2 Take the watch apart to make the most of all the components. Reattach some cogs and gears if you think it looks bare, and set aside any pieces not required for this project. If desired, move the pieces around to add more interest. Mix the 2-part epoxy glue in a small plastic cup and use it and the cocktail stick to adhere the extra bits.

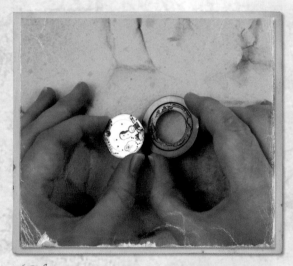

INQUIRE WITHIN

The brass ring I used already used has a useful raised lip, so it was unnecessary for that medal. Experiment with all sorts of frames, but make sure they are a good weight to hang well.

Step 3 Mix up another batch of the epoxy glue and apply it all around the inside edge of the donut hole. Place the watch part on the glue so the interesting side faces up through the hole. Leave it to set completely.

If you want to distress or color your metal surround, now is a good time to do that. I added a bit of alcohol ink to my aluminum medal and, when it was dry, distressed the edges with fine sandpaper.

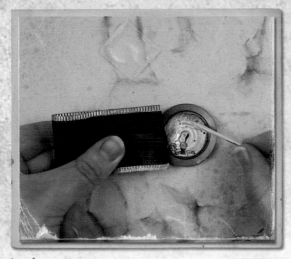

Step 4 Fold your ribbon in half and glue it to the back of the watch plate. (If your kilt pin doesn't have hanging loops, thread the ribbon through the pin at this stage.)

INQUIRE WITHIN

Look for interesting striped grosgrain and taffeta ribbons in unusual colors. If they seem a little bright, you can always dim the colors a bit by dipping the ribbon in a cup of hot black tea. This will give them an aged effect.

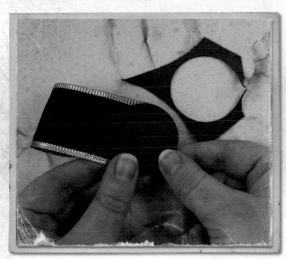

Step 5 Cut a circle of the leather, felt or non-fraying fabric the same size as the metal surround, and glue it down to cover all the messy inside areas. Make sure the glue goes all the way to the edges to stop the cover from peeling back with use.

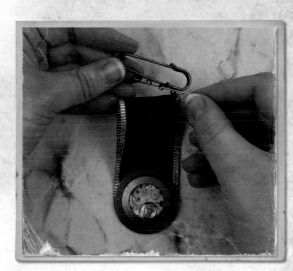

Step 6 Very neatly sew the top of the ribbon to the hanging loops on the kilt pin.

INQUIRE WITHIN

If you prefer for your pin to be completely hidden, you could sew a regular broach finding to the back edge of the back ribbon, so it has no visible means of support. If you have a long medal bar, you could thread a few medals onto it and hang them all at once!

Adventurer's Necklace

THROUGH THE RED SWIRLING MISTS OF MARS, the jungle drums were sounding their war cry. With an explosion of heat, a geyser erupted on the path directly ahead. With all exits now cut off, Captain Pip and his trusty sidekick had nowhere left to turn. Then a shapely arm, covered in tribal trinkets, beckoned through the fog. Without hesitation, they set off in pursuit.

The beautiful Martian and her equally lovely handmaidens hid them from her tribe for many moons, teaching them how to survive on the strange rocklike fruit thrown up by the geyser, and to bathe in the warm volcanic water. When eventually their distress flare brought a regimental escape gurney, Lord Barham (to be) gently took the Gorgonops tooth necklace from the neck of the sleeping Martian and stole away into the night.

SUPPLIES

White polymer clay

Translucent polymer clay

Brass filigree ring (I used Vintaj 24mm filigree ring)

0.6mm brass wire

Sheet mica (from Objects and Elements)

Black StazOn inkpad

4 9mm etched jump rings

6 7mm jump rings

10 5mm jump rings

0.4mm brass wire

Heishi beads (from Objects and Elements)

About 7 garnet and amethyst tumble chips

Focal bead (I used a 1" [2.5cm] diameter rainbow jade disk)

2 large open copper cogs (Tim Holtz Sprocket Gears)

22" (56cm) length suede lace

4 brass necklace ends to fit the suede lace

Clasp (I used a 27mm × 9mm etched creative bar from Vintaj and another Tim Holtz Sprocket Gear)

EQUIPMENT

Pasta machine (for conditioning and rolling out the clay)

Tissue blade or craft knife

Flat-nose pliers

Wire cutters

Round-nose pliers

Sharp scissors

Drill or hole punch

Rubber stamp (I used Ink and the Dog clock plates)

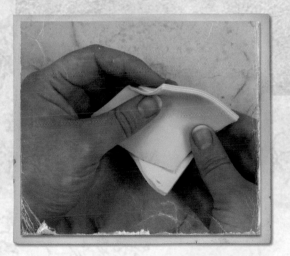

Step 1 Using the pasta machine, condition and roll out both colors of clay to a medium thickness. Layer them on top of each other, cut this slab in half and layer them again so you have 4 alternating colors. Try to keep a fairly neat rectangle. Run this layered sheet through the pasta machine. Cut it in half and layer it. Repeat this until you have a slab about 1" × 1" × 2" (2.5cm × 2.5cm × 5cm).

Step 2 Using a tissue blade, roughly cut the side profile of a big tooth in the clay, replace the pieces you cut off and turn the slab over 90 percent of the way. This will give you a stable base to cut exactly the same profile again, but this time it will make the front and back curves. Remove all the clay, and you should have a squared-off tooth shape with lots of lovely stripes.

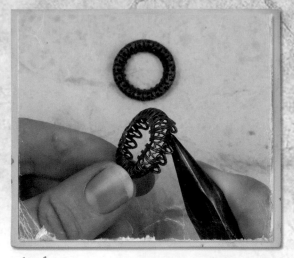

Step 3 Round off the sharp edges using the tissue blade or craft knife. You may need to do it a couple times on each edge to completely round them. Gently stroke the clay with a finger along the stripes to smooth it. Try not to blend the stripes; just make a nice ergonomic shape. Slightly curve the tooth until it looks suitably ferocious.

Step 4 Use flat-nose pliers to pry open the filigree shape and gently reshape it into a cap for the tooth. Work your way around the ring, slowly adjusting the shape only a little bit each time you go around.

INQUIRE WITHIN

You could use all sorts of things for the top of the tooth—an open metal ring, a cog, an ornate ring or some fancy wire work.

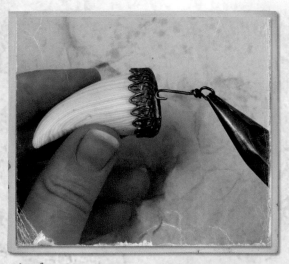

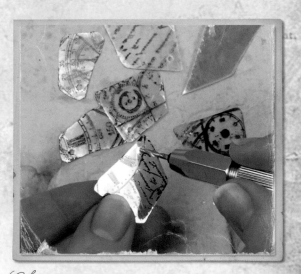

Step 5 Ease the ring into place on the top of the tooth, reshaping if necessary. Cut a piece of 6mm wire about 3" (7.5cm) long. Create a wrapped loop at one end (see Wrapped Loop on page 113) and trim the other end to ¾" (2cm). Make a hook on the end with round-nose pliers. Push the wire down into the top of the tooth and smooth the clay back into place around it. Bake according to the clay manufacturer's instructions and allow it to cool.

Step 6 Cut the mica into 2 natural-looking shapes with a craft knife or very sharp scissors. Be gentle; mica is quite fragile. Drill a small hole in the corner of a piece (not too close to the edge). Use your thumbnail to gently separate each tile into 2 pieces. Stamp the pieces with the StazOn ink and allow it to dry. Drill a small hole in the corner of each piece, not too close to the edge.

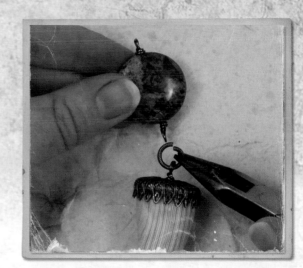

Step 7 Press all around the filigree with pliers to fully secure the tooth. Make a wrapped loop with 6mm wire at the top and bottom of the focal bead. Attach the cooled tooth to one loop with an etched jump ring.

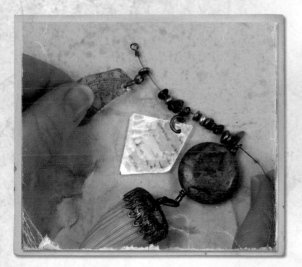

Step 8 Thread 7mm jump rings through each mica tile and close them. Link two 5mm jump rings to the first jump ring. Make a wrapped loop at the end of a 0.4mm piece of wire. Thread on the Heishi beads, tumble chips and mica tiles. When you reach half of the wire, thread on the focal bead and tooth. Continue adding the Heishi beads, tumble chips and mica tiles on the other side.

When everything is threaded, make another wrapped loop at the other end. Trim any excess wire.

Step 9 Attach the large copper cogs to each side of the beaded segment using an etched jump ring on one side and 7mm jump ring on the other.

Cut the suede lace in half. Fold one piece of lace in half and pass the folded loop end up through the cog. Thread the loose ends through the loop and pull tight.

Secure the ribbon findings to each of the four ends of leather lace. Thread a 5mm jump ring onto the ribbon findings from one side of the necklace and close. Attach half of the clasp to the 5mm jump ring using a 7mm jump ring. Repeat this on the opposite side for the remaining clasp.

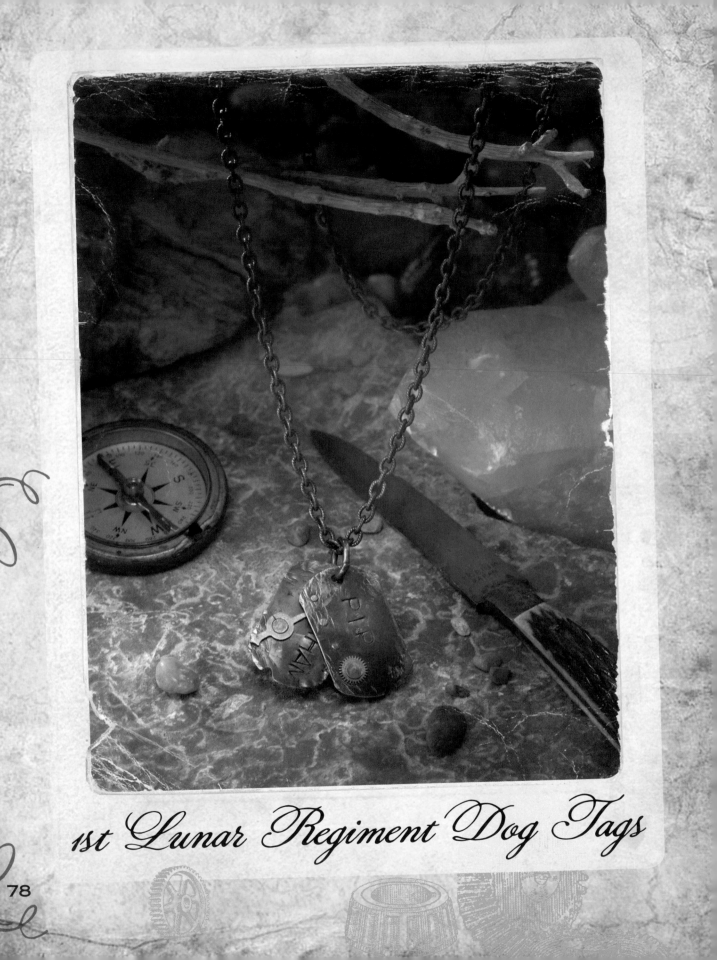

1st Lunar Regiment Dog Tags

WHEN THE ONLY REMAINING TRACES OF CAPTAIN PIP WERE A SET OF IDENTIFICATION TAGS HANGING FROM A BRANCH, HIS ARISTOCRATIC FAMILY FEARED THE WORST. Having surreptitiously attached a tracking device to the regulation regimental tags, they really should have realized that their son would soon have discovered the surveillance and made a bid for freedom.

After his grand tour of the less salubrious areas of the Empire—leaving behind a wake of broken hearts, leveled buildings and impressive dueling scars—he returned to the bosom of his family and was reunited with the tags. Fortunately, on his travels he had learned a few tricks and was able, with a few small modifications, to transform the tags from a trailing mechanism to a fine shortwave radiophonic device, capable of picking up the latest tunes from Vienna, Lyra and London.

SUPPLIES

2 BRASS DOG TAGS (I USED VINTAJ ALTERED BLANKS)

SMALL COG OR WATCH PART

NAILHEAD RIVET

BLACK ACRYLIC PAINT

ABOUT 2" (5CM) OF 1MM THICK WIRE (I USED SILVER-PLATED COPPER WIRE)

LARGE JUMP RING

BRASS CHAIN (LONG ENOUGH TO GO OVER YOUR HEAD)

EQUIPMENT

METAL BENCH BLOCK

SANDBAG OR PIECE OF RUBBER

MASKING TAPE

METAL LETTER PUNCHES

HEAVY HAMMER (16 OZ)

PLASTIC HAMMER

DRILL WITH 1MM BIT OR METAL HOLE PUNCH

NEEDLE FILE

WIRE CUTTERS

RIVET HAMMER

TISSUE

TABLETOP VICE

FLAT FILE

INQUIRE WITHIN

To imprint the letters onto the tag, you need to hit the punches pretty hard. Practice on a piece of scrap metal. I try to hit each letter just once, in case the punch moves.

Step 1 Place your metal bench block on a sandbag or piece of rubber to absorb the shock from hammering. Decide where you will place the letters (use a bit of masking tape to mark the bottom edges if needed). Hold the desired letter punch onto the metal tag and give the top one sharp, hard rap with the hammer.

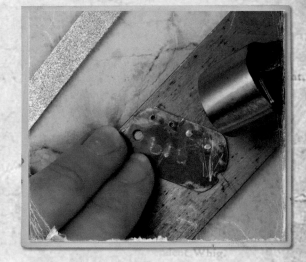

Step 2 If the punching has distorted the tag, hit it with a rawhide or plastic mallet to flatten it again. You can also add extra texture by hammering the edges to give it a distressed look.

Mark where the rivet holes are going to be and punch or drill them out. Make sure there is enough space for the cog or watch part. File the edges smooth, if necessary, and check to make sure the 1mm wire will fit through exactly.

Step 3 Place the cog on top of its appropriate hole and thread the nailhead rivet through (the front of the rivet is shown in step 4). Snip the stem off so only about 1/16" (2mm) sticks up through the hole. The wire cutters will have squashed it a bit, so file this end until it is completely flat.

Using the rivet hammer, gently tap all around the edge of the stem, curving and flattening the "corners" into a mushroom shape that won't pull through the hole.

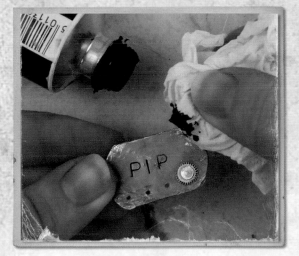

INQUIRE WITHIN

You can also use permanent markers and alcohol inks to color inside the letters if your tag is made of a shiny metal. Simply draw or paint onto the surface, wait for the inks to dry and then gently sand off the unwanted areas with a superfine sanding pad.

Step 4 Dab black acrylic paint over the letters, making sure it gets right down into the grooves. Rub it off the main part of the tag with a bit of tissue, ensuring that paint remains only in the letters.

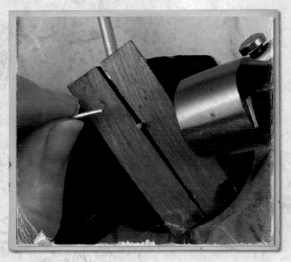

Step 5 To make the tiny wire rivets, cut several pieces of wire about 1" (2.5cm) long. Pop one in the vice with about ¼" (6mm) showing. In the same way that you created the back of the nailhead rivet, file the top of the wire flat, and then tap gently all around the "edge" to make a little dome. It doesn't have to be huge, just big enough not to pull through the hole. The more you hammer, the bigger it will get.

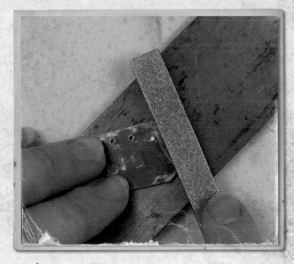

Step 6 Place your newly made rivet in one of the tag's empty holes and snip off any excess wire to about ¹⁄₁₆" (2mm). File the cut wire flat. Create the back of the rivet by hammering the wire in the same manner as you did in step 5. Practice will make perfect with these!

To complete the necklace, thread the two tags onto a large jump ring and hang them from a chunky chain (see Opening and Closing a Jump Ring on page 114). Rather than adding a clasp, join the cut ends of the chain together as you would a jump ring; or, if the links are soldered, use a jump ring.

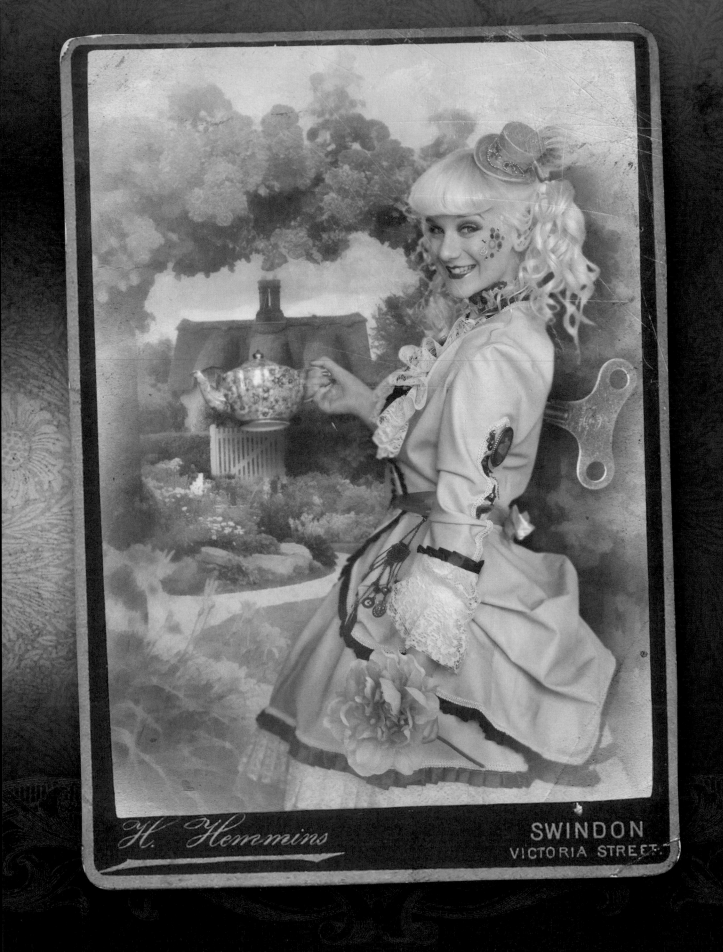

H. Hemmins

SWINDON
VICTORIA STREET

Clockwork Tea Party

---◈---

Dear Mr Rivett,

As we were flying over the extraordinary world of Automatopia, the balloon started to lose altitude. Mr Woppit did his best, but slowly and surely we descended into some rose gardens adjoining an exquisite château. A delightful creature came running out to meet us, a pretty clockwork doll, who is the benevolent ruler of these lands.

Her name is Princess Estrella Chronometer, and she invited us in for tea while her scuttlebots replenished our fuel tanks. Every kind of mechanical wonder is contained within the château, all built by the Automata citizens. We ate some most delicious cake and were offered several types of tea, including Ganymede Pouchong—which, as you know, is practically unobtainable these days. The Princess then took us on a tour of the citadel, where Mr Woppit caused quite a stir. I'm afraid he rather showed off, to tell the truth.

As we returned to our transport, the generous inhabitants pressed exquisite gifts on us, and Estrella bestowed on us the freedom of the city, signified by an ornate key. It was with some regret that we continued on our way, but I have no doubt we shall return one day.

Love,

Emilly

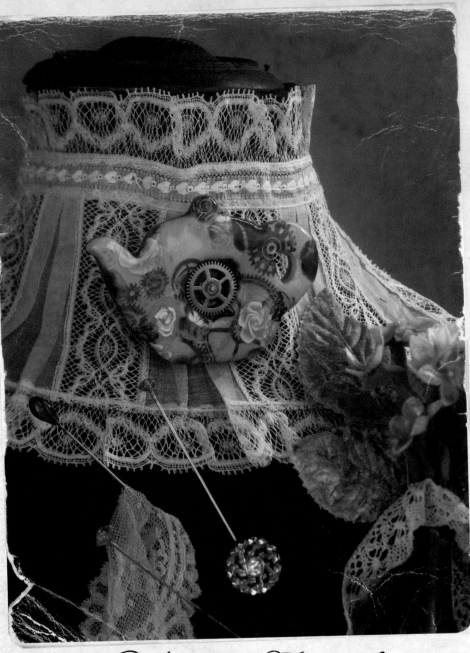

Teapot Brooch

ONE OF THE FOUNDATIONS OF ANY SOCIETY IS ITS SOCIAL RITUAL OF DRINKING HOT BEVERAGES (or so I am told by that famous anthropologist Mr Pitt Rivers). Nowadays, no matter on which planet you may take your afternoon pause, you will be offered tea. Others have expounded at length upon the delights of Europa blend and Oceania Chai, and I was fortunate to try both, poured gracefully from lovely teapots by a clockwork creation named Kizzywik.

Kizzywik's teapot collection is extensive. There are chintz ones, china ones, crystal and cut-glass ones, and every teapot is used only for a specific tea blend. I was enchanted by the mechanism inside that stirred the tea leaves continuously to allow perfect saturation of flavor.

Mr Woppit wouldn't drink it, as he likes only engineer's tea, white with two sugars, from his special mug.

SUPPLIES

Scrap clay (mine was brown)

Polymer clay, cream and lavender

StazOn ink pad (I used Timber brown)

Polymer clay millefiori canes (mine came from assorted Etsy shops; I prefer cane made from Kato Clay because they keep a firm shape)

Liquid polymer clay

Gold powder

A cog, about $\frac{1}{2}$" (1.5cm) in diameter

Brooch finding

EQUIPMENT

Brayer

Teapot-shaped cookie cutter

Craft knife

Tile

Pasta machine (optional, for making the skinner blend and for rolling an even thickness)

Rubber stamps (I used the cogs stamp from Ink and the Dog's clock plates series and swirl design from Laurence Llewelyn-Bowen)

Tissue blade

Modeling tool (like a large needle)

Heat gun

Sandpaper

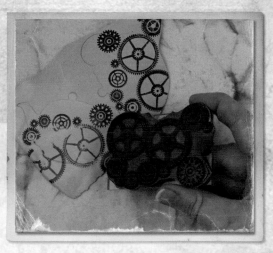

Step 1 Roll out the scrap clay to about $\frac{1}{8}$" (3mm) in thickness. Using the cookie cutter, cut out the teapot shape. If you don't have a cookie cutter, you could trace around a drawn template with a craft knife. Cut out the inside of the handle, too. Then, right in the middle of the pot, cut a circle approximately $\frac{1}{4}$" (6mm) larger than the cog. Place the clay on a tile or baking tray and bake it according to the clay manufacturer's instructions.

Step 2 Create a skinner blend (see Skinner Blend on page 118) and roll it out to $\frac{1}{16}$" (2mm) thickness. Use the cookie cutter to very lightly impress a guide of where you intend to cut your teapot out. This will help with positioning the stamp and millefiori. Stamp over the shapes outline with the StazOn ink. You don't need to press hard, just lightly transfer the ink. Don't worry if it's not perfect, you can cover any gaps with millefiori.

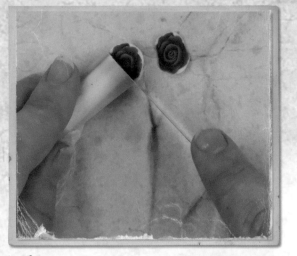

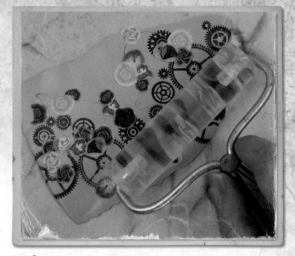

Step 3 Using the tissue blade, slice the millefiori canes into paper-thin slices. It takes a bit of practice to get a lovely sliver. Rotate the cane after each slice to keep the round shape. Don't worry if you get only half or three-fourths of the flower, you can use these pieces for the bottom of the layers. (The parts of the clay that look white are actually translucent; they will go clear when baked.)

Step 4 Add a layer of the millefiori flowers to the skinner blend over the stamped areas. Use any broken slivers at the bottom and place perfect flowers over the top to conceal any breaks. Build up bouquets of flowers between and over the stamped areas. Use a brayer to roll the millefiori level with the skinner blended clay. Using hardly any pressure, roll the brayer first in one direction and then in the other to minimize distortion.

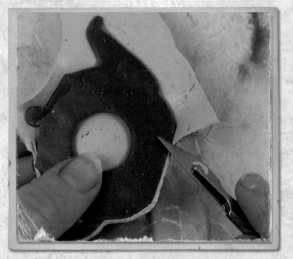

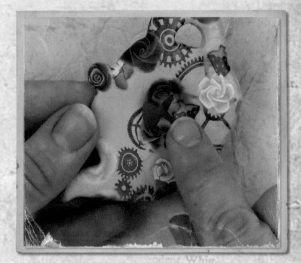

Step 5 Rub a tiny bit of liquid clay all over the top and sides of the scrap clay base. Don't use too much; it should only be sticky. Make sure you get into all the nooks and edges of the cutout shapes. The liquid clay helps the unbaked clay stick to the baked clay.

 Place the decorated clay over the base and gently smooth over the edges. Cut the decorated clay flush with the baked back edge using a craft knife.

Step 6 Cut a small X in the center of the circle and smooth the clay on those edges. Do the same for the teapot-handle cutout shape. Use a modeling tool to press the clay firmly against the sides while maintaining a rounded, smooth look. Smooth and polish the surface with the tip of your finger to eradicate any fingerprints, but be careful not to smudge the ink.

INQUIRE WITHIN

Gold powder goes absolutely everywhere, so I suggest you do this well away from your clay and wash your hands before gently stamping the gold swirls all over the teapot's surface.

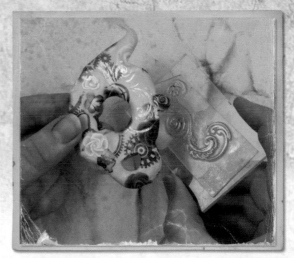

Step 7 Dip your finger in the gold powder, shake most of it off and lightly dust the second rubber stamp. As with the gears stamp, you don't have to make an indentation. Just touch the clay to the stamp's surface. Place it on the tile and bake it again. Allow it to cool.

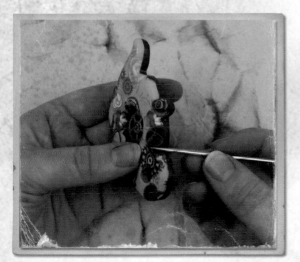

Step 8 Roll out the remaining scrap clay to ¼" (6mm) thick. Rub the back of the baked piece with liquid clay and place it on the rolled clay. Using the craft knife, trim the soft clay flush with the edge of the teapot. Cut out the handle hole but not the circle in the middle of the teapot. Smooth around all the edges with a knitting needle or modeling tool.

Add the gear by pressing its central pointed pin into the clay. If it has a hole in the center, thread it through a rivet and press that in. (If you like, you can glue it in place after baking for extra security.)

Place it on the tile and brush liquid clay on the front surface and sides to glaze. Bake as before.

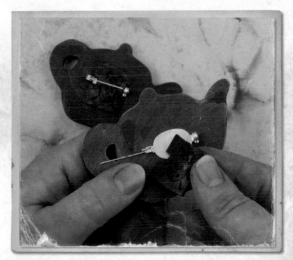

Step 9 Clear the glaze by heating it with a heat gun, just as though you were melting embossing powder. You will see it get shiny; don't overdo it, or you will burn the clay! Allow it to cool.

Sand the back of the piece with coarse sandpaper for a textured finish. Add a brooch back by cutting a square of clay big enough to cover the finding, brushing it with liquid clay and pressing it firmly onto the brooch back, sandwiching the pin finding between. Bake it for the last time, glazed side upward. Allow it to cool before wearing.

Clockwork Princess's Chatelaine

AT LADY ELSIE'S FINISHING ACADEMY FOR YOUNG LADIES OF TEMPERAMENT AND FORTUNE, the graduation present is one of Pearson's Popular Patented Personal Chatelaines. The students may graduate only when they can say this forty times after a glass of champagne and with a mouthful of cherry pips.

It is therefore not to be wondered that these elegant accessories are much sought after.

They are very useful for carrying small tools and essential items of everyday use. For the aspiring writer, perhaps they hold a small notepad and propelling pencil; for the musical, a tuning fork and baton would be invaluable. It is perhaps best not to speak of the box of sugar lumps and filigree absinthe spoon attached to Lady Elsie's own accessory.

SUPPLIES

Filigree piece (I used a Vintaj 51mm Gerbera Petal Filigree)

Brass rectangle tag (I used a Vintaj large rectangle Altered Blank)

Powder pad

Stamp (I used a swirl)

Embossing stamp pad

Black embossing powder

Embossed brass heart charm

Pink metal paint (I used alcohol ink mixed with a bit of mica powder)

Additional assorted charms and beads; I used:

Open brass cog (Rings and Things)

55mm gate key (Vintaj)

25mm clock (Vintaj)

Silver filigree key

10mm purple crystal briolette

Tiny vintage locket

1" (2.5cm) vintage key

1" (2.5cm) old brass cog

½" (1.5cm) brass heart bead charm

0.4mm brass wire

Filigree ring or cog (I used a Vintaj 24mm filigree ring)

6 total ¼" (6mm) and ½" (1.5cm) flower beads (I used assorted polymer clay roses, but glass flower beads would look lovely, too)

12 total pieces of various brass chains in the following lengths:

6 chains 1" (2.5cm) long

5 chains 2" (5cm) long

1 chain 3" (7.5cm) long

1 2-to-1 connector (I used Vintaj 14mm × 18mm 3-hole filigree)

Assorted jump rings (I used three 9mm etched rings, two 7mm and twenty-three 5mm)

Toggle part of a loop and toggle clasp

EQUIPMENT

Nylon-jaw pliers

Nylon mallet (optional)

Round-nose or bail pliers

Flat-nose pliers

Heat gun

Wire cutters

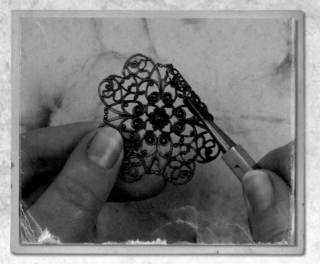

INQUIRE WITHIN

Often, embossing powder sticks all over metal, not just in the stamped areas. This method in step 2 produces perfect results every time.

Step 1 Flatten the filigree piece, using either nylon-jaw pliers or gently hammering with a nylon mallet on a hard surface. Use the round-nose pliers (or bail pliers if you have them) to gently curve the top two petals over toward the front. Keep curving them until they form a rolled bail; the tips of the petals should just touch the rest of the filigree.

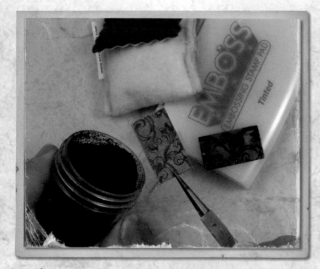

Step 2 Tap the brass rectangle with the powder pad until it is covered with white dust. Stamp the design onto it with the embossing ink, pour the embossing powder on top and tap it gently to remove the excess powder, leaving just the design. Hold the edge of the tag with pliers and melt the powder with a heat gun.

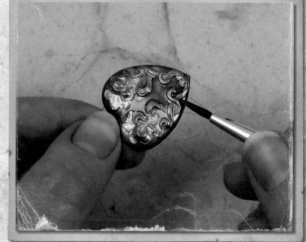

Step 3 All metal charms can be further enhanced by adding color. For this charm shown in the photo, I just mixed a bit of alcohol ink with some iridescent mica powder and dotted it over the background, avoiding the raised areas so the original brass was still visible. It's fairly roughly done, just to add a bit of extra interest. If you want, you can go all out with intricate neat painting, using enamels and a teeny paintbrush: size 000. Embellish the remaining charms as desired.

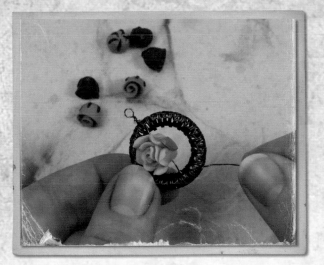

INQUIRE WITHIN

If desired, you can make a long necklace with this chatelaine. Make a long bead necklace that incorporates the loop part of the toggle clasp as a pendant, and then thread the toggle through the loop.

Step 4 For the pomander, cut a 6" (15cm) length of 0.4mm wire. Make a wrapped loop at the top and thread it down through the gaps in the ring's filigree (see Wrapped Loop on page 113). Add the large rose and continue the wire down through the gaps in the bottom of the ring. Add a rosebud to the wire, facing out the same side, and secure the wire as before. Add a final rosebud on this side. Repeat with 3 flowers on the other side, wrapping the end of the wire securely before trimming the excess wire.

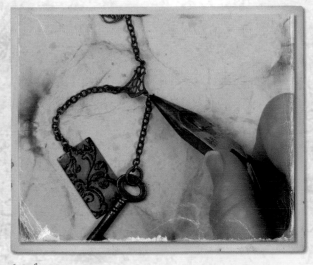

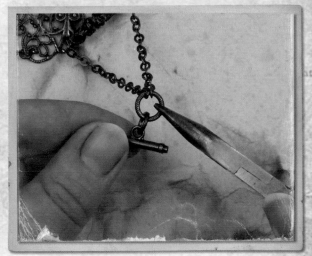

Step 5 Attach a 1" (2.5cm) length of chain to the top of the 2-to-1 connector with a small jump ring (see Opening and Closing a Jump Ring on page 114). Attach the other end to the bottom center of the filigree. Attach the brass tag and a vintage key to 2 lengths of chain using small jump rings, and add them to the connector, also with jump rings.

Step 6 Attach all the rest of the charms and components to the filigree using appropriate jump rings and wrapped loops where needed.

 Thread the 3" (7.5cm) length of chain through the filigree bail. Thread the ends through an etched jump ring (use 2 small jump rings as a step-up if your chain is too fine to thread onto the large one). Attach the toggle to the etched ring with a 7mm ring.

 Use the toggle to attach the chatelaine to a waistcoat buttonhole.

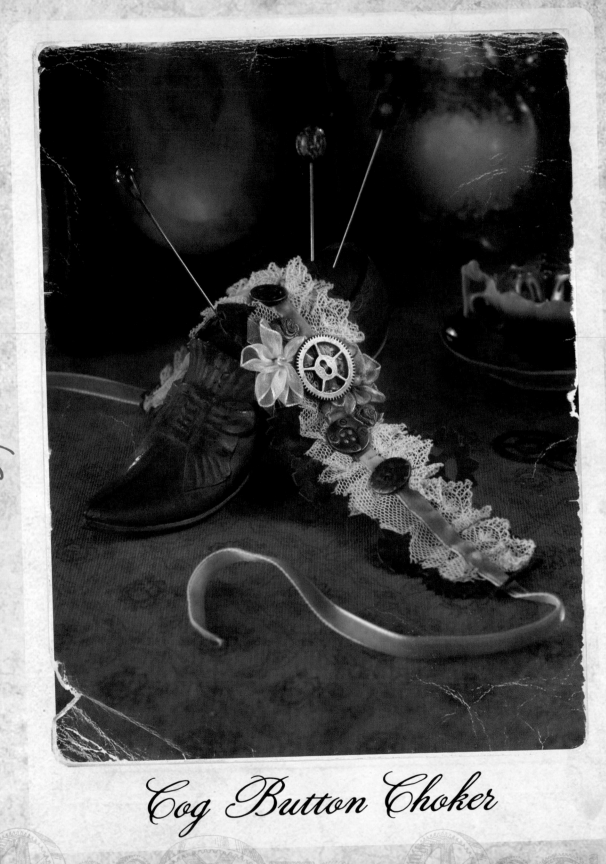

Cog Button Choker

IT IS A TRUTH UNIVERSALLY ACKNOWLEDGED THAT A CLOCKWORK DOLL IN POSSESSION OF A COMPLICATED MECHANISM MUST BE IN WANT OF A COG.

For that reason, every sensible doll and automata designer keeps on their person, at all times, a fine selection of spares. There is no reason why these pieces may not be elegant as well as functional, displayed so prettily that no one may suspect the mechanical nature of its owner's origins.

This delightful piece has been entirely fashioned from bits and pieces found lying around the workshop of Herr Döktor. Leather straps from the workshop chair, cogs and buttons from the cracks in the floor—oh, and he claims the lace was part of a present for his lady love (although he was spotted wearing a flamboyantly frilly lace jabot at dinner last week).

SUPPLIES

Piece of thin brown leather (or faux leather) at least 10" × 2" (25.5cm × 5cm)

20" (51cm) piece of 1" (2.5cm) wide white lace

25" (63.5cm) of ¼" (6mm) wide pink velvet ribbon

4 ½" (11.5cm) decorative brads or rivets

Cog button or cog

Ribbon roses

EQUIPMENT

Ballpoint pen

Assorted cogs to draw around

Sharp scissors

Craft knife

Hole punch

Brewed black tea, still warm

Strong thread

Needle

Leather needle

Flat-nose pliers

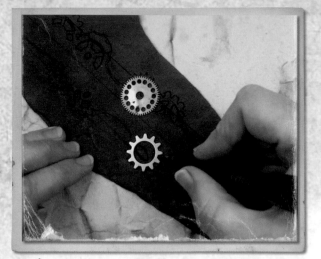

Step 1 On the suede (back) side of the leather, draw a line 10" (25.5cm) long down the length of the leather piece. On each side of this center line, draw parallel lines 1" (2.5cm) from the center. These are your top and bottom guides. Using these markers, draw around your cogs at different intervals. Make them look as if they are interlocking, but don't make the shapes too complicated. Just use the cogs as guide shapes—you can make the teeth designs simpler, if needed.

Step 2 Carefully cut out the leather design. Use the sharp scissors to go all around the outside first, cutting out the cog shapes roughly and then going back and cutting in the teeth. Where there aren't cogs, just cut a smooth curve to the next cluster. Add detail with a craft knife, cutting out all the little spokes. Finally, use a small hole punch to create the centers of some cogs for extra interest.

Step 3 Tea stain the white lace by dunking the lace in a cup of strong black tea for a couple seconds. When the lace achieves the desired color, take it out and let it dry.

To ruffle it, secure your thread at one end with a knot and then run a gathering stitch all the way up the center of the lace.

Step 4 Pull the thread while pushing the lace down to ruffle it. Adjust the ruffled lace to the correct length and stitch it to secure the length. Layer the ruffled lace on the front of the leather piece down the center.

Place the center of the velvet ribbon in the center of the choker along the middle of the lace ruffle. It will have excess length at each end that you will use to tie it up with. Using the leather needle, sew the ribbon to the leather, starting where the lace ends. Sew along each edge with tiny stitches, holding it down firmly. Tie the thread using your favorite method to secure the lace and ribbon.

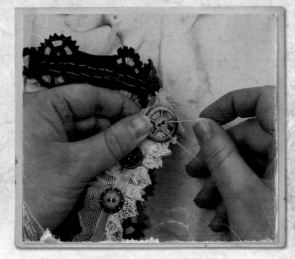

Step 5 Push the brads from the front through all layers until the prongs push through the back of the leather. Use the flat-nose pliers to bend the points in place.

Step 6 Finally, sew the cog button on the front, along with the ribbon roses, to create a pretty cluster at the center front. You could also make an asymmetrical choker with 3 brads on one side of the button and one on the other.

Clockwork Hatpin

DOUBLING AS A LOCK PICK, KNITTING NEEDLE AND, AT A PUSH, A WEAPON, A LADY'S HATPIN IS ONE OF THE MOST IMPORTANT ADVENTURING ACCESSORIES. This thrilling example of the art has twice been used as an impromptu ice pick. Once, whilst its owner was climbing in the Ice Mountains of Lyssaria Four, and once at an ambassadorial dinner party when there was an accident with the refrigeration device.

The jaunty feather comes from the plumage of the rare mint julep bird, sadly almost hunted to extinction for the pleasing peppermint aroma of its plumage. Obviously, these plumes were willingly donated by a living example of the breed, only too happy to oblige such a charming personage as Miss Ladybird in return for a biscuit.

SUPPLIES

Polymer clay, pink and pearl

Hatpin (or a smaller stickpin) and protective end cap

Liquid polymer clay

2 brass filigree bead caps (I used Vintaj 12mm filigree bead cap)

About 25 antiqued brass headpins

0.4mm antiqued brass wire

4 charms or small clock parts (I used a tiny cog, a clock hand and teeny key from Vintaj, and a brass heart charm)

Gold acrylic paint

Gold leaf (optional)

Polymer clay-compatible lacquer

Feathers, approximately 3" (7.5cm) long

Round crystal bead that can thread onto the hatpin (I used an 8mm round Swarovski mint alabaster crystal)

EQUIPMENT

Chain-nose pliers

Needle tool

Cocktail sticks

Wire cutters

Cornstarch

Paintbrush

2-part epoxy glue

Small plastic or paper cups

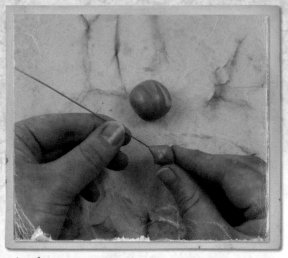

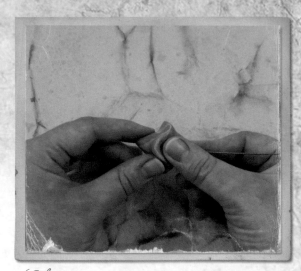

Step 1 Condition the clays separately and then blend walnut-sized pieces of the pink and pearl together to create a lovely raspberry-ripple effect. Take a large pea-sized piece of the clay and roll it into a ball around the top (not sharp) part of the pin. Use your fingers to mold it into a bicone shape, and bake according to the manufacturer's instructions. (This gives you a stable base to sculpt on.) Allow it to cool before continuing.

Step 2 When cool, rub the baked clay with a tiny bit of liquid clay. Wrap the rest of the clay around it, completely enclosing it. Make this part as large or small as you like by adding or removing clay. Create a large bicone shape with your fingers or a flat tool. To make the waves, place your thumbs on opposite sides of the bicone edge and push. Create 4 ups and 4 downs, and try to keep them even.

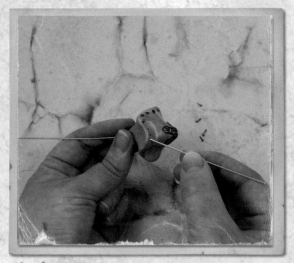

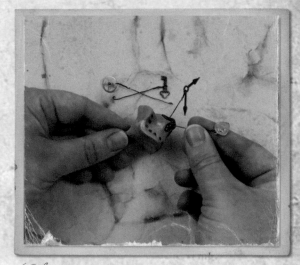

Step 3 Using the pliers, open the end caps until they will fit prettily on the top and bottom of the shape. Press the top end cap into position. Using a needle tool or cocktail stick, make a hole in the center of the top bead cap down through the clay, where the feathers will go. Create tiny holes all along the top edge of the wave and insert the headpins, snipped down to about ¼" (6mm) so the heads look like rivets.

Step 4 Cut four 6" (15cm) lengths of wire. Thread each charm onto a piece of wire, fold over about 1" (2.5cm) and twist tightly until it holds the charm in position (the charms should stick up in various directions). Trim the wire to about 1" (2.5cm) in length. Make a tiny hook shape at the bottom of the wires (to stop them from pulling out of the clay). Insert the wires at equal spaces through the top filigree shape and into the clay. Bake the piece, supporting it on a bed of cornstarch if necessary.

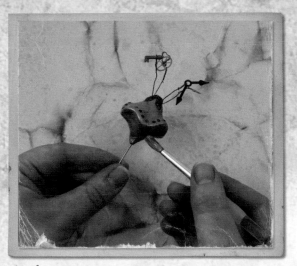 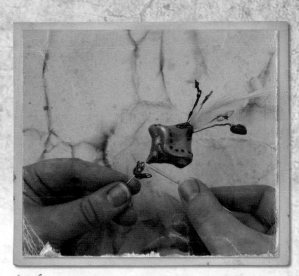

Step 5 Paint the underside of the clay shape with gold acrylic paint. You may need several coats to get good coverage; you could even use two shades of gold for subtle blending. While the paint is still tacky, gently place tiny pieces of gold leaf all over the shape; it will immediately stick to the paint. Press it down into place with the tip of your finger and let it dry.

Step 6 Glaze the gold part with a polymer clay-compatible lacquer for strength (see Glazing on page 121).

When the lacquer is dry, thread the bottom end cap onto the hatpin and fit it snugly to the bottom of the clay portion. Mix up some 2-part epoxy glue. Using a cocktail stick to dab on tiny amounts in the right places, adhere the end caps and feathers.

Thread the round crystal onto the bottom of the hatpin and glue it in place against the bottom end cap. Finally, curve the charm wires into a pleasing arrangement around the feathers.

An Appendix of Useful Items and Practical Methodology

There are such a huge variety of tools and materials available that finding the right thing for a job can be quite daunting. I have listed and explained all my favorite things and techniques, but there are plenty more you may find easier to obtain or preferable to use. If you have a better way of doing something or a more exciting component than the one I've used, by all means, follow your instincts!

Remember, practice makes perfect for basic skills, so try the appropriate technique for your project on scrap pieces before using your more precious materials.

SUPPLIES

Bezels

A bezel is an edged shape that can be used to hold a flat-backed stone or to pour resin into. They come in all sorts of shapes, sizes and depths. Some have hanging loops attached for pendants; others are attached to rings, cufflink backs or earring studs. You can also find interesting objects to make your own bezels. Try bottle caps, for example.

Cabochons

A cabochon is a flat-backed, unfaceted stone of any shape. Most usually are oval or round. They can be real stones like malachite or opal, or faux pieces created from polymer clay, resin or other materials. They are usually either glued into a bezel or impressed into polymer or silver clay as part of a larger project.

Chain

Both long and small bits of chain are useful. I often recycle old broken lengths and am a happy recipient of friends' discarded oddments. You can also take apart chain made from enormous loops to make interesting jump rings. There are some gorgeous fancy chains currently available for purchase that add a wonderful touch to steampunk projects. I particularly like the range of natural brass chains from Vintaj.

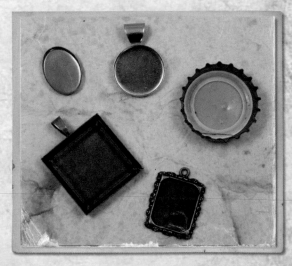

AN ASSORTMENT OF BEZELS

AN ASSORTMENT OF BEADS AND CHARMS

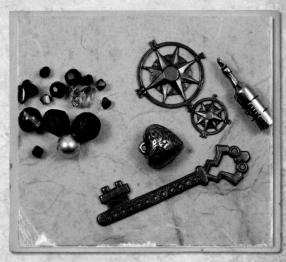

Charms, Beads and Crystals

Look out for unusual charms with steampunk motifs, and collect them so you have a little stash of interesting charms, like tiny clock faces, airships, submarines, corsets and top hats.

Buy the best-quality beads you can for art jewelry. Real stones, real pearls and high-quality glass will look better and last longer than cheap plastic, and they will often cost only a few pennies more. You can even take apart old necklaces from thrift stores and use their lovely beads in new pieces.

I use only Swarovski crystal for faceted sparkling designs. The Austrian company still produces the best and most long-lasting sparkle of any crystal bead. The shape I use most often is the bicone. Do feel free to substitute your own bead color and shape choices throughout the book. Try to make each piece your own rather than copying exactly.

Filigree

Filigree is a wonderful way to add vintage styling details to your pieces without having to carve or engrave it yourself! A huge range of metals and shapes are available with elegant designs embossed and stamped out, leaving a fine, lacelike effect. The metal is usually soft enough to sculpt and bend around other objects, creating interesting settings and backgrounds for your work.

Findings

Findings are the general name given to all those oddments needed to finish off a piece of jewelry. Some examples are clasps, brooch backs, earring wires or "fishhooks" and jump rings. Headpins are long, blunt pins; you can get fancy ones or pins with plain ends. Eye pins are a piece of wire with a loop on one end. Headpins and eye pins are used to thread beads and also are used as dangles or connectors. Calottes, necklace ends and ribbon ends are all used to finish off the thread, thong or ribbon you have strung your beads onto.

Found Objects

Natural and synthetic found objects can add a story element to your pieces and make them truly unique. Sea glass created from old bottles polished by the waves and sand are favorites of mine. I've also picked up some wonderful rusty washers and gorgeous shells. Stones, twigs, bits of rock, broken components, old fairground tokens and vintage ephemera are all perfect.

AN ASSORTMENT OF FILIGREES

AN ASSORTMENT OF FINDINGS, FEATURING HEAD-PINS OF ALL WIRE TYPES, EAR WIRES AND LOBSTER CLAW CLOSURES

Glitter and Inclusions

You can add things to resin and polymer clay to make interesting and realistic faux stones and textures. I love very fine micro glitters for a magical effect, but natural inclusions like dry, rough coffee grounds, bits of mica and seeds, as well as embossing powders, can be fun, too.

Glues

The most useful glue for adhering metal to other materials (and to itself) is 2-part epoxy glue. I use the brand Araldite. Other craft glues like UHU are handy for tacking things in place, like leather or ribbons, while you attach them in a more permanent way. Be wary of superglue, as it often dries white and will dim your beads and crystals.

Leather

Every adventurous steampunk needs leather! There are also many wonderful faux leathers and suedes for vegans and vegetarians. Buy it in either sheets or thong lengths. It's perfect to rivet metal cogs to and can give a manly and bold look to jewelry pieces.

Lockets

Lockets were very popular Victorian items. They look like a pendant but can be opened to reveal the inside. They often held a picture of a loved one or a lock of hair. Why not reduce a picture of your own beloved to fit inside?

Paint

I use a lot of paint to color and distress my jewelry. I mainly use acrylics in dark browns and blacks for aging polymer clay. I also use bright-colored alcohol inks and enamels or metal paints for metal. Have an experiment to see which combinations of paint and other materials work best for you. Always test pieces before using on a gorgeous "almost finished" item.

Polymer Clay

Polymer clay feels a little like plasticine and can be modeled in the same way, but when it is baked it fuses together and creates a lovely solid shape. There are lots of brands on the market; Fimo, Sculpey, Cernit and Kato are just a few. Each

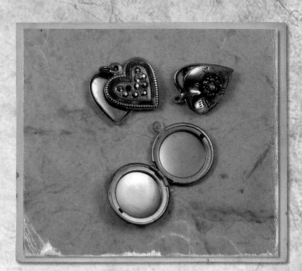

AN ASSORTMENT OF LOCKETS

AN ASSORTMENT OF RIBBONS AND LACE

brand has its own idiosyncrasies, and many artists prefer one or another for their own particular style. I mainly used Premo! Sculpey in this book because I like its sculpt ability (although I do use Kato for millefiori canes, as it keeps a lovely firmness that is essential for cutting thin strips). Liquid polymer clay is also useful. It needs to be baked to set (just like normal clay) but will act as a glaze for your pieces or even as a glue to bond baked pieces together.

Resin

I use 2-part epoxy resin called ICE Resin for all the projects in this book. It is a 1-to-1 mix and dries completely clear. However, it can take up to 48 hours to dry, so you must be very patient. Always follow the manufacturer's instructions exactly when using resin. Use exactly the right amounts and mix them for the recommended amount of time. You could also try UV resins on most projects in this book. These can be set much more quickly under a UV acrylic nail lamp. It's easy to color your resin with tiny amounts of oil paint.

Ribbon and Lace

For a soft and feminine vintage look, odds and ends of pretty old ribbons and lace can be tea dyed (just dip them in a cup of hot black tea and dry) for a creamy color. Look for natural fibers, cotton silk and velvet for a truly Victorian feel.

Shrink Plastic

This does exactly what it says: It is plastic that shrinks when heated. You can write on it and color it before shrinking to create some stunning tiny objects and charms. Colors intensify enormously when shrunk, so do play a bit before making a perfect piece! There are lots of different types and brands; the one I use most is "Shrinkles" frosted.

Silver and Metal Clays

There are two main brands of silver clay: PMC and Art Clay World. Much like polymer clay, both brands have admirers but basically do the same thing. The main products feel like potter's clay and can be sculpted and rolled before drying, sanding and finishing, and then firing and polishing. There are also liquid and paste types and even a paper one for origami-style pieces. They are designed to be fired with a blowtorch or in a kiln, at which point the clay burns away, leaving the silver particles to fuse together. During this process the piece does shrink slightly, so details (and imperfections) become more

AN ASSORTMENT OF SMALL GLASS VIALS AND THEIR TOPS

noticcable. Art Clay World also makes a "low fire" version that can be fired on a normal cooking gas ring. The disadvantages are that it dries out faster and is more expensive per gram than its equivalent, sheet precious metal. There are other metals now available, including copper and bronze, but at the moment they need a kiln to fire properly.

Vials

Tiny glass bulbs now come in a variety of shapes and sizes. Fill them with colored liquid, glitter or mica flakes, and use them as a mad scientist's miniature experiments for charms and pendants. They have little lids with hanging loops, too.

Wire

Wire comes in an assortment of gauges and sizes as well as colors and hardness. Most jewelry wire is not too stiff but will comfortably hold its shape if knocked. Never cut wire with scissors; you will notch the blades. I love to recycle copper wire from old lengths of electrical cable. The wire I use most often in this book's projects is 0.4mm wire (i.e., 26 gauge).

EQUIPMENT

Cutters

A pair of small, sharp wire cutters is essential. Mine are specially designed for jewelry makers and have nice little blades and a pointed tip. For cutting thick chunky, electrical-style or toughened wire, use a small jeweler's saw or a big chunky pair of pliers.

Drills

Sometimes you need a hole in something that is too hard to just push through. That is when you need a drill. There are some lovely small electric hand drills made just for the hobby market, like Dremel. But if you don't want to spend a load of cash, why not try a tiny pin drill, as used by railway-model enthusiasts? They take more work but are accurate, and you can change the drill-bit sizes just like a Dremel. If you only ever want to punch small holes through sheet metal, try a tiny screw-down hole punch. These give lovely, perfect holes—usually one widget has two hole sizes available.

Files and Sandpaper

To achieve professional results, finishing is very important. Some materials, like silver clay, need to be beautifully sanded and finished prior to firing. This cuts down on harder finishing work later. Other materials, like polymer clay, can be sanded after baking to give a rough or smooth texture. For coarse sanding, ordinary sandpaper is fine; but for superfine sanding and polishing, you need wet and dry papers or mesh of grades 400 to 1,000 or more. It is laborious, but the final piece will look so much better. Honest.

Knives

A craft knife is invaluable for precision cutting of paper, plastic and clay. Small disposable craft knives are also useful in this respect. Tissue blades are long, wafer-thin razors with one sharp edge. Great care must be taken when using them, but they are essential for some polymer clay techniques like cutting millefiori and mokume gane.

Metal Stamps and Textures

These are great tools for distressing or imprinting on metal. You can write words or sentences with the letters and make

WIRE CUTTERS

AN ASSORTMENT OF KNIVES

METAL STAMPS AND TEXTURES

patterns and pictures with the others. They are made from toughened steel, and you need something firm like a steel bench block on a hard rubber mat to place underneath as you strike them with a hammer.

Modeling Tools

I love my set of metal dentist's tools! I bought them at an army surplus store many years ago when I was a student. They are fabulous for small-scale sculpting. But pretty much anything can be made into a modeling tool—the end of a pencil, a pin head, a looped bit of wire, a cocktail stick with a bead stuck on the end. There are lots of inexpensive sets designed specifically for polymer clay. I urge you to experiment and make or find your own favorite tools.

Needles

A needle tool is great for piercing through beads, making holes in pendants and for sewing! I have a variety, from tiny and fine sewing types for threading silk ribbon to chunky darning needles, used for sculpting and piercing (and for which I made a polymer clay handle).

Pasta Machine

This is a rather odd but essential tool for the serious polymer clay artist. It enables you to roll clay out to a uniform thickness every time—even to wafer thin. It also cuts down considerably on the time spent conditioning clay. Don't use the same machine you use for making pasta though. It's best to keep craft and food tools separate. You should clamp it to the edge of the table to keep it steady while you roll the clay through. Always start on the thickest setting and slowly decrease the thickness to avoid stressing the machine. It's also used for some specific techniques, like the skinner blend (see page 118). There are specific ones sold for polymer clay, but I use one intended for pasta that I received as a wedding present. It has done sterling service for my polymer clay but has never made linguine.

Pliers

There is a bewildering assortment of pliers available but the absolute essentials are round-nose pliers for making little loops and flat-nose pliers for gripping and making right angle-bends.

MODELING TOOLS

A VARIETY OF PLIERS

I also use needle-nose pliers, which are similar to the flat-nose pliers but have a longer tapering tip. A pair of nylon-jaw pliers are also useful for flattening filigree and working with wire because they won't scratch. Bail-making pliers are quite fun, too—they can create a cylinder shape from a small, flat piece of metal or filigree.

All these pliers are extensions of your hands and fingers, so it's worth investing in good quality. They will last longer and be nicer to use for long periods of time.

Rollers and Brayers

Sometimes a pasta machine is not the right rolling tool. For gently blending and flattening polymer and silver clay, a small hand roller or brayer is invaluable. You can use acrylic rollers sold for sugar craft or rollers designed specifically for polymer or silver clay. Mine has a little handle like an old-fashioned lawn mower, which is sweet, but a plain acrylic tube works just as well.

Stamps and Texture Plates

Almost anything can be used to add texture to clay—the rough side of a shell, an old filigree necklace clasp or traditional stamps with Victorian themes. I love using rubber stamps with clock themes. You need stamps with fine, deep detail. Look for quirky steampunk-related images you'll use again and again. There are also texture plates sold specifically for use with clay, some of which are quite elegant. The lace and letter scripts are particularly good.

ROLLERS AND BRAYERS

STAMPS AND TEXTURE PLATES

USING VINTAGE ITEMS

I think a large part of the "punk" in steampunk comes from making things yourself, using items in a way they were not intended and being inventive with found objects and vintage parts. You can find vintage pieces in garage sales, thrift and charity shops, online at eBay and Etsy, or even at the bottom of your own jewelry box. Broken things can be taken apart for their components, shiny things distressed to look old, and old things shined and polished to look new. The only limit is your imagination.

Taking a Watch Apart

It's very important not to destroy valuable pieces, so before you do anything at all, make sure the watch has no monetary terms or sentimental value! If it's broken, can it be fixed? If not, you can take your watch apart for the bits.

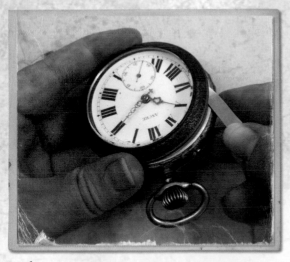

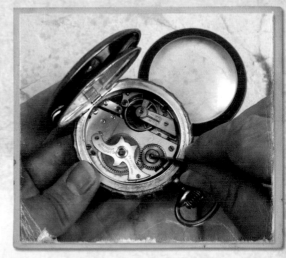

Step 1 Carefully take off the back and the glass front—pretty much all backs and fronts either unscrew or need to be levered off. There are special watchmaker's tools available for this, but you can also use a knife blade or thin screwdriver. Be very careful when using blades, as they can snap under pressure. And wear eye protection when necessary.

Step 2 Start undoing every little screw you can find. You will need an absolutely tiny screwdriver. A set of jeweler's or watchmaker's tools are useful, but I've also found that the tip of a broken craft knife works well.

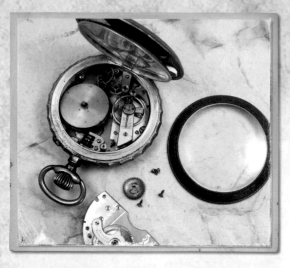

Step 3 As pieces become loose, remove them. Keep all the tiny pieces in a small jar—they are just as useful as the large parts. Some pieces may be held in place by pressure rather than screws, so be careful that they don't go flying off into the room!

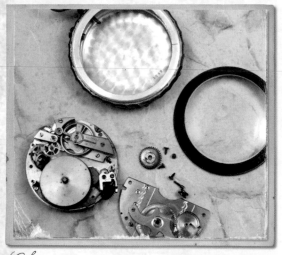

Step 4 Continue removing larger connected pieces until the watch case is empty.

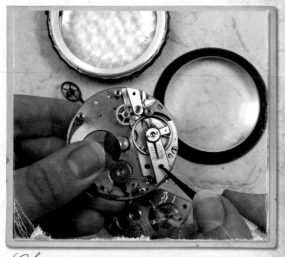

Step 5 Using the watchmaker's tools, begin unscrewing pieces of the watch parts.

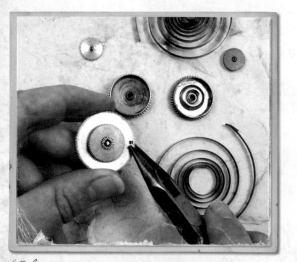

Step 6 Some pieces that look solid may have other bits inside them. Pictured above is the mainspring case, which reveals a lovely spring when pried open with pliers!

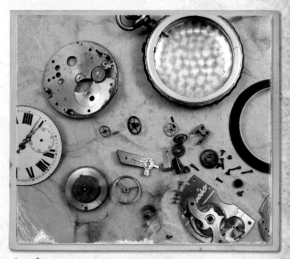

Step 7 Continue unscrewing any parts that were hidden by the clock face until you have a pile of pieces ready to create with.

Pieces You'll Find in Watches

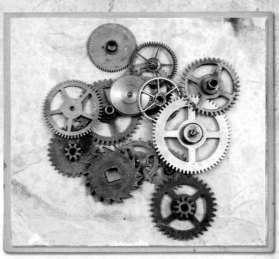

Watch Faces

On the front, of course, is the clock face. These are often enameled with copper and will crack if bent or manhandled. The face is often held in place by two copper prongs. Try to locate these and gently ease them out of their holes without flexing the face.

Cogs and Gears

A cog is, in fact, just the tooth bit of a gear wheel or sprocket, but for the less pedantic it covers any of these lovely steampunk icons. You'll find large ones, about an inch, inside clocks, and teeny ones inside watches.

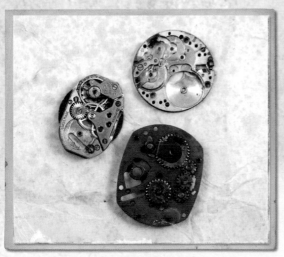

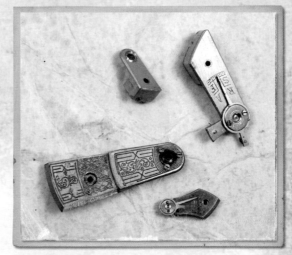

Bridge Pieces

There will probably be several "bridge" pieces of different shapes and sizes inside. Some vintage bridge pieces are absolutely exquisite with etched detailing. You will also see tiny red gems—these are rubies (both synthetic and real) meant to allow moving parts to rotate without friction and wear. They add gorgeous dewdrops of color to your pieces.

Regulators

A regulator is often the most beautifully engraved piece of a watch. It is used to set the rate of oscillation of the balance wheel, helping the watch not to gain or lose time.

CLEANING AND MENDING VINTAGE FINDS

Not everything in steampunk has to look as if it's old and battered. The industrial processes of the Victorian age made shiny new items more affordable than ever before, so revel in the bling of your highly polished brass and steel.

I polish dingy metals using a rotary tumbler (such as those used by rock-polishing kits) filled with assorted shapes of stainless steel shot (i.e., nonrusting) and a drop of cleaning compound, all of which are available from websites selling silver metal clay. Within an hour, most pieces are supremely shiny. You can polish chains, too, but be warned that they will get tangled.

If you don't want to spend any money, you can do what the medieval knights made their squires do with chain mail: Pop your piece in a canvas bag with some dry sand and shake it for ages until any rust and imperfections have been abraded off. Then polish it with a soft cloth and some Brasso or a similar metal polish.

Once your pieces are clean, you may decide you actually really like them just as they are. If they were just broken, try repairing them with the jewelry-making techniques you're going to learn.

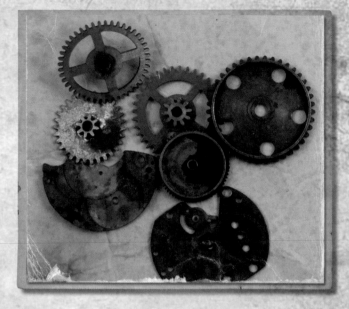

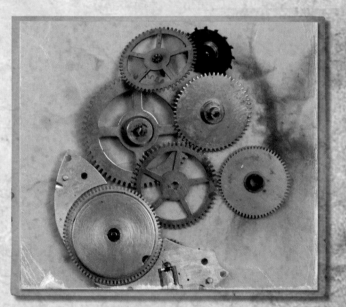

Distressing and Coloring
New Items

I love the look of rusty ancient bits and pieces, but real rust poses some practical problems. Another dilemma occurs when a perfect component is shiny silver and you want it to look brass. A most satisfying solution to these problems is to change a component's superficial appearance by distressing it yourself. A few suggestions to achieve these looks follow.

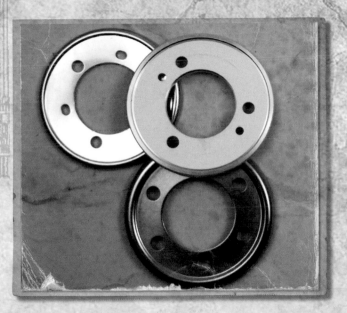

PAINTS AND ALCOHOL INKS

First take the shiny item and quickly sand it with fine sandpaper, just to help the paints adhere.

Lightly dab texture paint over it in some areas. Don't swamp it. Try to imitate the way real rust might build up. I use Ferro paint from Viva Decor in rust color; it has little flakes of metal in it, which makes a lovely texture and dries really fast. Experiment with your own favorite gels and mediums to see what you like best.

Finally, drop a bit of alcohol ink into the recesses. Use a tissue to wipe color off the raised areas for highlights. Blend the colors if you like, and use blending solution to remove if it all gets a bit dark. I use Ranger alcohol inks, which dry within seconds, but you could experiment with other things like metal paints and enamels, which are tough-wearing but slow-drying.

PATINAS

There are many patina and aging kits available. Polymer clay artist Christi Friesen has used some commercial kits to great effect on her pieces. You don't have to stick to metal either. You can age and distress polymer clay, paper, wood and bone, too.

Other techniques to try include heating metal to change or deepen the color and using liver of sulphur to provide a black patina on silver. Patinas on metals can be sealed by the application of Renaissance Wax, which forms an invisible protective coating.

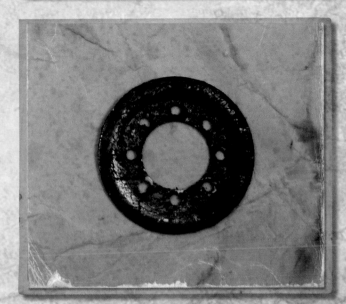

JEWELRY TECHNIQUES

Making a Loop

Step 1 Grip the round-nose pliers about 1" (2.5cm) from the top of the wire.

Step 2 Twist the pliers 90 degrees away from you, creating a right angle in the wire.

Step 3 With your free hand, curve the top piece of wire back toward you, shaping it tightly over the top jaw of the pliers.

Step 4 Keep curving until it crosses the other piece of wire and then remove the round-nose pliers.

Step 5 Slide the wire cutters inside the loop, so the cutting edge is flush with the inside edge of the wire circle, and snip.

Wrapped Loop

Step 1 Grip the round-nose pliers about 1" (2.5cm) from the top of the wire. Twist the pliers 90 degrees away from you, creating a right angle in the wire.

Step 2 With your free hand, curve the top piece of wire back toward you, shaping it tightly over the top jaw of the pliers.

Step 3 Keep curving until it crosses the other piece of wire, and then remove the round-nose pliers.

Step 4 Grip the loop in flat-nose pliers.

Step 5 Start wrapping the tail around the stem wire very neatly. Wrap three times close together.

 Using the wire cutters, place the cutting edge flush with the edge of the wrapped coil and cut off the excess wire, leaving the stem intact.

Step 1 Using two pairs of chain-nose pliers, hold each side of the cut opening. Twist in a scissorlike fashion. Do not pull the ring apart, or it will not return to a perfect circle.

Step 2 To close, grip each side of the ring with the pliers and twist back again.

Ribbon Ends

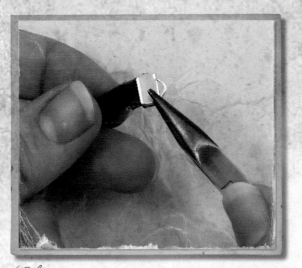

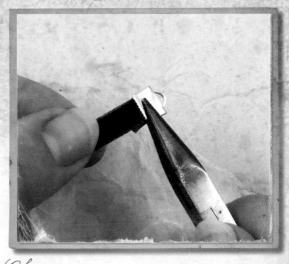

Step 1 When using crimp ribbon ends, place a dab of glue on the end of the ribbon. If the ribbon is very fine, fold over a small portion of the ribbon end to give the metal something to bite on.

Place the crimp ribbon end over the end of the ribbon. Using the chain-nose pliers, squeeze the bend in the crimp to press the crimp together.

Step 2 Squeeze the sides of the ribbon end to securely clamp it to the ribbon. Allow the glue to dry thoroughly before wearing.

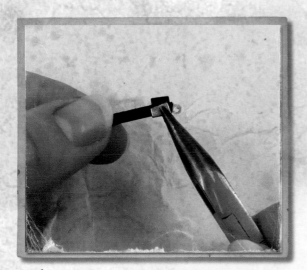

Step 3 If you're using cord tips, place a dab of glue on the end of the ribbon or leather cord. Using the chain-nose pliers, fold over one side of the tip and squeeze it shut.

Step 4 Fold over the other side and squeeze it shut. Allow the glue to dry before wearing.

POLYMER CLAY TECHNIQUES

Conditioning

Step 1 Using a tissue blade, slice the clay brick into thin pieces. Slightly overlap the pieces as you layer them on your work surface.

Step 2 Run the overlapped clay through the pasta machine on the thickest setting.

Step 3 Fold the clay mass in half, and repeat step 2. Continue to do this, gradually resetting the pasta machine to thinner settings, until the clay mass is smooth and pliable.

Step 4 If the clay crumbles when you run it through the pasta machine, put a piece of paper underneath to catch the crumbs. Press the crumbs together and repeat step 3 and 4 until the crumbs are incorporated back into the clay mass and the clay is smooth and pliable.

HOW TO MAKE MOLDS

You can make your polymer clay take any shape you desire by making a mold for it. You can choose almost any object to make a mold from, but I recommend starting simple until you get the hang of popping the object from the mold. Great objects to begin with include shells, beads and pendants, keys and other objects that are easy to press in and remove. Molds can be made in two forms: hard and soft.

To make a hard mold, condition enough polymer clay to have about twice the volume of the object to be molded. Roll it into a ball and flatten it slightly. Spray the clay with water (to aid in release) and press the object firmly in. Gently pull the item out again, being careful not to distort the mold. Bake the mold according to the manufacturer's instructions and allow it to cool before using.

Soft molds are made most easily using a two-part silicone modeling putty (often sold in places that supply silver clay). This method is best for delicate pieces or for those pieces with undercuts, which will benefit from the mold flexing to enable release. Simply mix equal parts of the compound together until they are fully blended. Press your objects into it and wait until the compound has completely set to a slightly firmer but still rubbery form. Pop the object from the mold, and the mold is now ready to be used.

Skinner Blend

Step 1 Roll equal amounts of conditioned clay into two balls.

Step 2 Form the balls into teardrop shapes and press them together.

Step 3 Flatten the clay slightly and form it into a rough rectangle.

Step 4 Pass the clay rectangle through the pasta machine on the thickest setting, multicolored edge first.

Step 5 Fold the clay in half, matching the colored edges, and run it through the machine again, folded edge first.

Step 6 Repeat step 5 as often as necessary (10-20 times) to get a beautiful, even blend.

Baking

I recommend using a small toaster or craft oven that is dedicated to polymer clay baking, especially if you use polymer clay on a regular basis.

If polymer clay is infrequently used in your projects, using your home oven is fine, but you should tent aluminum foil over the pieces before placing them in the oven to bake. And after you're finished baking and the oven has cooled, wash the inner walls of the oven with baking soda and water. Following these tips will help keep your home oven safe for food preparation.

Whatever oven you use, always bake your clay in a well-ventilated area.

To bake the clay, begin by laying the clay piece(s) onto a ceramic tile or baking sheet. Support large or awkwardly shaped pieces on a bed of cornstarch. (Dust or wash off the cornstarch after baking but before glazing.)

Bake the clay according to the clay manufacturer's instructions. (Different clays bake at different temperatures—always check manufacturer's instructions for the correct baking times and temperatures.) Also, always allow for the full amount of baking time to ensure your clay piece will be fully baked.

When the time is complete, turn the oven off, open the oven door and allow the clay to cool completely before removing it from the oven.

Sanding

Dry and baked polymer clay can be sanded to help achieve a smooth look for your finished pieces, make a lovely surface to apply glaze and be a pleasure for the wearer because you've removed potentially irritating bumps and snags. Dry metal clay can be sanded to help achieve a smooth surface after firing. Needle files are useful for smoothing out tiny spaces, like the holes you punch for jump rings.

Start with fine wet and dry sanding paper or a block of grade 400 and sand evenly while the piece is wet. Gradually work your way down through the grades of paper to 1,000 or more. Buff and polish the piece to a high shine using a buffing wheel or a piece of cloth.

Glazing

Step 1 Place the piece of baked clay onto the work surface.

Step 2 Using a paintbrush, apply a layer of liquid polymer clay to the baked clay.

Step 3 Return the piece to the oven to set, following the polymer clay manufacturer's instructions for temperature and timing. This picture shows the clay with the polymer clay completely cooled.

Step 4 After the glaze has set, you can either leave it matte or heat it to a glasslike shine with a heat gun. Don't overdo heating it with the heat gun, or the clay will bubble. You can see it change texture, just as embossing powder does. This picture shows polymer clay that has been heated to a shine.

121

Acknowledgments

The Beau Brummell medal for exquisite taste and decorum is awarded to my wonderful models Teri Aldersey, Emma Brackenbury, Kit Cox, Rhona Macdonald and Kimberly Rose Gardner.

The Goldbug Bursary for international treasure hunting and objet d'art *acquisitions was won by Terry Shook, Jean Guittet and Lynne Hardy.*

The R.L. Stephenson Prize for feats of technical daring and literary adventure goes to the North Light team, especially Tonia, Julie and Kelly, and also to my optical magician Julian Holtom.

The Gilbert and Sullivan Awards for unfailing support and enthusiasm in the face of eccentricity are given to my wonderful family, Ma, Pa, Roz and Nik, and also all members of The VSS, along with Emilly Ladybird's supporters, steampunkers and Woppits the world over.

HARRISON — CENTRAL MUSIC HALL STUDIOS — CHICAGO.

About the Author

JEMA HEWITT IS A JEWELRY ARTIST AND COSTUME DESIGNER.
She designs and creates unique fanciful *objets d'art* and also writes books and articles to inspire others to do the same. She lives among the rolling hills of Derbyshire in the United Kingdom with her husband and beloved menagerie.

Miss Emilly Ladybird, Adventuress, is Jema's steampunk alter ego. In the character of Emilly she travels the world searching out artifacts for her employers, Dickens and Rivett. You can follow her ongoing adventures on Twitter and read more about Dickens and Rivett Steampunk Emporium at www.steampunkjewellery.co.uk., and join Emilly at www.facebook.com/emillyladybird.

Resources

Steampunk Organizations and Resources

These are just a few of the many groups and organizers out there, just to get you started.

BRASS GOGGLES
forum, blog and worldwide information
www.brassgoggles.co.uk

THE VICTORIAN STEAMPUNK SOCIETY (UK)
www.thevss.yolasite.com

THE NOVA ALBION STEAMPUNK EXHIBITION (CONVENTION)
www.steampunkexhibition.com

STEAMCON (CONVENTION)
www.steamcon.org

STEAMPUNK MAGAZINE
free and downloadable
www.steampunkmagazine.com

THE STEAMPUNK WORKSHOP
blog of exciting steampunk projects
www.steampunkworkshop.com

Suppliers

All these suppliers will ship internationally.

OBJECTS AND ELEMENTS
ICE Resin, ephemera and findings
www.objectsandelements.com

VINTAJ NATURAL BRASS COMPANY
art metal, filigree and findings
www.vintaj.com

Q-WORKSHOP
Unusual dice
www.q-workshop.com

PAPERARTSY
rubber stamps, inks and paints
www.paperartsy.co.uk

POLYMER CLAY CENTRAL
for information, supplies and advice
www.polymerclaycentral.com

TREASURE CAST, INC.
cog-shaped and unsusual buttons
www.tcisteampunk.com

Other Resources

ETSY
for buying and selling interesting supplies and finished pieces
www.etsy.com

EBAY
for old watches and vintage bits and pieces
www.ebay.com

Steampunk Books and Graphic Novels

These are just a few of my personal favorites.

The Difference Engine by Bruce Sterling and William Gibson; a dark and gritty steam book

Larklight by Philip Reeve; a fun family friendly steampunk adventure trilogy

The Court of the Air trilogy by Stephen Hunt; a more fantasy-based steam adventure

20,000 Leagues Under the Sea by Jules Verne; a classic from the Victorian era

Girl Genius by Kaja and Phil Foglio; a fun adventure graphic novel series (www.girlgeniusonline.com)

The League of Extraordinary Gentlemen by Alan Moore, illustrated by Kevin O'Neill; a graphic novel for mature readers

The Baker Street Irregulars by Tony Lee and Dan Boultwood; graphical tales of mystery and irreverent adventures by Sherlock Holmes's army of mudlarks

Interesting Steampunk Artists, Interior Decorators and Sculptors

Here are just some of the people whose work I enjoy.

CHRISTI FRIESEN: www.cforiginals.net
DANIEL PROULX: danielproulx.blogspot.com
DOKTOR A: www.mechtorians.com
JACK UNION: www.facebook.com/jackunion1885
MODERN VICTORIAN: www.modvic.com
MOLLY CRABAPPLE: www.mollycrabapple.com
DATAMANCER: www.datamancer.net
HERR DÖKTOR: herrdoktors.blogspot.com

Some Steampunk Musicians and Bands

Steampunk is a varied genre as far as music is concerned; these are an eclectic selection of my personal favorites.

ABNEY PARK
DR. STEEL
THE CLOCKWORK QUARTET
SUNDAY DRIVER
THE COG IS DEAD
VERNIAN PROCESS
GHOSTFIRE
THE MEN THAT WILL NOT BE BLAMED FOR NOTHING
EMILIE AUTUMN

Index

1st Lunar Regiment Dog Tags, 78–81

absinthe, 47–48

Absinthe Fairy Charm Bracelet, 61–63

Absinthe Fairy Interlude, 46–63

Absinthe Glass Charms, 52–55

Adventurer's Fob Watch, 66–69

Adventurer's Necklace, 74–77

Aether Pirate Cravat Pin, 38–41

alcohol inks, 33, 37, 50, 54, 59, 72, 90, 111

artists, Steampunk, 125

Atlantean Starlight Necklace, 16–19

Atlantis, 11–12, 17, 21

Atlantis Expedition, 11–25

Azure Cog Earrings, 20–23

Babbage, Charles, 8

bands, Steampunk, 125

baubles, 12–15, 30–33

beads, 22, 37, 55, 59, 77, 100–101

bezels, 13, 41, 58, 69, 100–101

blowtorch, for firing, 26

books, Steampunk, 125

bottle caps, 100

bracelets, 24–27, 61–65

brads, decorative, 95

brass plates, 14, 31

brass rings, 72

brass wings, 50–51

Brass Wings Necklace, 48–51

brayers, 106

bridge pieces, 10

brooches, 84–87. See also pins

burnishing, 35

cabochons, 41, 100–101

chain, 36, 101
 silver, 19, 91

charms, 27, 37, 52–55, 59, 61–65, 100–101
 metal, 90, 97

chatelaine, 88–91

chatons, 41, 44–45, 69

choker, 92–95. See also necklaces

clasps, 15, 37, 51, 63, 102
 lobster, 19
 toggle, 91

clay. See also polymer clay
 art clay, 25–26
 firing, 26
 metal and silver, 25–26, 103
 polishing, 26

Clockwork Hatpin, 96–99

Clockwork Princess's Chatelaine, 88–91

Clockwork Tea Party, 82–99

Cog Button Choker, 92–95

cogs, 13–14, 17, 22, 25, 31–33, 44–45, 49–51, 68–69, 94–95, 109

colored pencils, 54

cookie cutters, 19, 85

copier, 35

crystals, 14, 19, 41, 51, 100–101

cufflinks, 56–60

cutters, 104

dangles, 59

dog tags, 78–81

dolphins, 17, 19

drills, 104

earring hooks, 23

earrings, 20–23

embossing ink, 90

embossing powder, 90

Empire Medal, 70–73

end caps, 98
 memory wire, 55

epoxy paste, 44–45

epoxy resin, 13, 44, 49, 103

equipment, 104–106

feathers, 99

Ferro paint, 50

Ferro rust texture, 33

files, 104

filigree pieces, 18, 62, 76–77, 90, 101–102

findings, 101–102. See also clasps; earring hooks; headpins; jump rings; loops

fob watch, 66–69

fossils, 69

found objects, 102

gears, 109

gel medium, 58

gemstones, 62

Gibson, William, 8

glitter, 13, 45, 49, 102

Glossy Accents, 58–59

gloves, vinyl or latex, 44

glues, 102

gold powder, 69, 87

graphic novels, 125

Green Fairy, 47, 53, 57

Green Fairy Cufflinks, 56–60

hatpins, 96–100

headpins, 15, 41

heat gun, 55, 87, 90

Heishi beads, 77

image transfer, 35–36

images, vintage, 58

inclusions, 102

ink, for distressing, 33. See also alcohol inks

interior decorators, Steampunk, 125

iridescent powder, 68, 90

Jeter, K. W., 8
jewelry techniques, 112–115
jewelry tumbler, for polishing, 26
jump rings, 15, 27, 37, 41, 51, 59, 63, 77, 81, 91, 114
Jurassic Valley Exploration, 64–81

kiln, for firing, 26
kilt pin, 73
knives, 104

lace, 94, 103
leather, 73, 94, 102
letter punches, metal, 79–80
liver of sulphur, 27
lockets, 60, 102
loops, 112–113. *See also* wrapped loops

Martians, 74
medal, 70–73
mermaids, 24
Mermaid Song Bracelet, 24–27
metal donut, 72
metal stamps, 104
mica tiles, 76–77
modeling tools, 44, 87, 105
molds, for clay, 40, 68–69, 117
musicians, Steampunk, 125

necklaces, 16–19, 34–37, 48–52, 74–77, 91. *See also* choker
needles, 105
new items
 coloring, 33, 37, 111
 distressing, 33, 37, 50, 59, 111

Oceans Gate Key Device, 12–15
organizations, Steampunk, 124–125

paints, 103, 111
 acrylic, 15, 40, 81
 gold acrylic, 99
 lacquer, 99
 metal, 50
 oil, 13

wiping off, 15, 69, 81
pasta machines, 75, 105
patinas, 27, 111
pearls, 15, 22–23, 27
Photoshop, 58
pins, 38–41. *See also* brooches
playing cards, 25
pliers, 18–19, 62–63, 69, 76, 105
Poe, Edgar Allan, 8
polymer clay, 14, 25–26, 32–33, 35–36, 40–41, 75–76, 85–86, 98–99, 103
 baking, 120
 canes, 61–62
 conditioning, 35, 40, 61, 75, 116
 faux stone technique, 14, 19
 glazing, 87, 99, 121
 liquid, 41, 69, 86
 marbled, 14
 millefiori canes, 86, 103
 sanding, 120
 skinner blend, 67, 85–86, 118–119
polymer clay techniques, 116–121
pomander, 91
porthole spacer, 13
postcards, vintage, 35
printer, ink-jet, 35

regulators, 109
resin. *See* epoxy resin
resources, 124–125
ribbon ends, 19, 51, 77, 115
ribbons, 73, 103
rings, 42–45
rivets, 32–33, 80–81
rollers, 106
rubber stamps. *See* stamps

sanding pads, for polishing, 26
sandpaper, 26, 36, 50, 104
scissors, fancy, 54
sculptors, Steampunk, 125
sea glass, 27
sheet mica, 75–76
shrink plastic, 54–55, 103

silver chain, 19
silver powder, 15
silver wire, 22
siren song, 24
stamps, 25, 32–33, 54, 68, 90, 106
Steampunk, 8, 124–125
Sterling, Bruce, 8
stickpins, 41
Storm Bringer Device, 30–33
supplies, 100–103, 124

tea, aging with, 73, 94
tea parties, 83–84
Teapot Brooch, 84–87
texture plates, 14, 33, 106
textures, 15, 36, 80, 104
tissue blade, 26, 32, 40, 61–62, 75, 86
tools, 104–106
trilobites, 69
tumble chips, 77

Verne, Jules, 8, 60
vials, glass, 49–50, 103
Victorian style, 8
vintage items, 59, 107–110
 cleaning, 110
 mending, 110

watches
 cases, 32, 67–69
 faces, 109
 parts, 14, 18, 25, 32–33, 67, 72–73, 107–109
 taking apart, 67, 107
Wells, H. G., 8
wire, 103
 brass, 36–37, 50, 55
 silver, 18–19, 22, 27
wrapped loops, 15, 19, 22–23, 27, 37, 55, 59, 91, 113

Zeppelin Pirate Attack!, 28–45
Zeppelin Pirate Necklace, 34–37
Zeppelin Skull and Cogbones Ring, 42–45
zeppelins, 29–30, 34

Continue Your Expedition

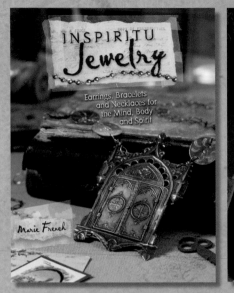

INSPIRITU JEWELRY

Earrings, Bracelets and Necklaces for the Mind, Body and Spirit

MARIE FRENCH

Inspiritu Jewelry is a book full of inspiration and techniques for creating rich and romantic-looking jewelry with a new dimension—that of using adornment to enrich the spirit and offer a sense of well-being. This book guides you through 25 jewelry "prescriptions." In addition to learning a variety of jewelry-making techniques, each piece suggests a particular benefit to the wearer—from learning patience to gaining protection on a journey and from offering forgiveness to remembering a loved one.

INSPIRED REMNANTS, CURIOUS DREAMS

Mixed Media Projects in Epoxy Clay

KERIN GALE

Inspired Remnants, Curious Dreams is your construction dream date to building whatever your creative mind can churn out. In this book, author Kerin Gale will introduce you to the incredible possibilities of using epoxy clay to make jewelry, lighting fixtures, accessories, decorative art pieces, a mirror, an evening bag, an aquarium and more! There are many things to discover about this clay and Kerin has much to share with you

OBJECTS OF REFLECTION

A Soulful Journey Through Assemblage

ANNIE LOCKHART

Objects of Reflection embodies visual journaling disguised in the form of dimensional assemblage. By finding uncommon ways to reinvent common objects, you'll learn how to create art that is so personal it resembles a page from your artist's journal. Inspiration pours from every page of the book through a gallery of projects designed by the author. In addition, 20 step-by-step techniques include tips for attaching elements with simple materials like string, wire and tape, aging objects, adding texture with modeling paste and more.